MICHAEL FREEMAN
THE COLOUR PHOTOGRAPHY FIELD GUIDE

The **essential guide** to colour for striking digital images

ILEX

First published in the UK in 2013 by

I L E X

210 High Street
Lewes
East Sussex BN7 2NS
www.ilex-press.com

Distributed worldwide (except North America)
by Thames & Hudson Ltd., 181A High Holborn, London
WC1V 7QX, United Kingdom

Publisher: Alastair Campbell
Associate Publisher: Adam Juniper
Managing Editor: Natalia Price-Cabrera
Specialist Editor: Frank Gallaugher
Editor: Tara Gallagher
Editorial Assistant: Rachel Silverlight
Creative Director: James Hollywell
Senior Designer: Ginny Zeal
Designer: Jon Allan
Colour Origination: Ivy Press Reprographics

British Library Cataloguing-in-Publication Data
A catalogue record for this book is available from
the British Library.

ISBN: 978-1-78157-989-3

Printed and bound in China

10 9 8 7 6 5 4 3 2 1

CONTENTS

INTRODUCTION

Color is a wonderful phenomenon. In images from
paintings to photos it can bring a pleasure that is
experienced rather than considered, in much the same
way as music. Color in photography is now much closer
to painting than ever before, not in the way it looks
but in the huge amount of control that digital cameras
and digital image editing give.

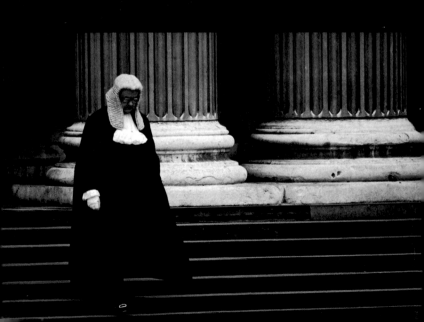

Color isn't just about hue and wavelength, and while it's important to understand the technical background in order to get the most from your camera and software, the real secret to making eye-catching and beautiful pictures is understanding the impact that color has on our eye and our mind.

Photography's black-and-white beginnings were overtaken when color film became widely available, and the richness and sensation of color were enthusiastically embraced by almost everyone. Monochrome has its place in photography (and indeed is enjoying a digital revival), but color will always be the major player in imagery. In the first chapter, I'll explain what makes colors the way they are—or rather, the way we see them—and how your camera's sensor captures them and turns them into a viewable image. However, color becomes meaningful only when it is perceived, and that requires the eye-brain combination—what is now known as the HVS (Human Vision System). The main idea behind this book is to teach you how to make full use of color's unique properties when you're shooting. Unique because we are able to actually enjoy it rather than just take it in as a matter of fact, in much the same way

that we enjoy music. Of course, what color combinations are pleasurable to the individual varies, just like music. This field guide will also help you with finding and choosing colors that you can expect to have an effect on the people who see your images. For instance, color has many and varied associations. There is, for example, the association of color with temperature. Red, orange, and yellow convey a sense of warmth, while blues and aquas trigger feelings of coldness. Color can convey state of mind, from alert and excitable (fully saturated yellow, orange), to contemplative and even melancholy (cool colors with low saturation). Color can signify status and desirability: think purple and gold. These triggers to our emotions have been used for centuries by painters and more recently by interior and product designers.

The entire digital photo workflow is now full of potential for managing color to perfection, which means being confident in reproducing color accurately, and also being able to interpret color according to the way you see, remember, and think about it. As we'll see, expressive color in photography goes beyond measurement into personal likes and dislikes—a direct result of color's unique ability to trigger feelings. Camera sensors capture more of the subtleties of color than ever before, and when it comes to processing the results, especially from Raw files, the possibilities are endless with the latest software. I'll be showing you how to use your eye as a tool which is ultimately more reliable than any measuring device.

MONOCHROME

A High Court judge walking down the front steps of St Paul's Cathedral in London. The white of his collar, wig, and cuffs provide a wonderful contrast against his black robes, and chimes nicely with the columns behind him.

THE LANGUAGE OF COLOR

Understanding color begins with familiarizing yourself with its special terminology. We all think we know what color means, but rarely do we have the need to think about it logically. As photographers, however, we need to. Color from your camera and on your screen is constructed from red, blue, and green, but we don't think about color in these terms.

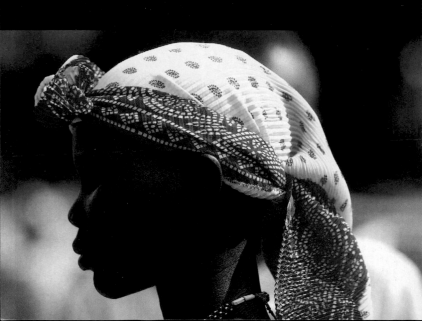

Instead, we think, when we have to at all, first about hue, and then about brightness and saturation. I'll explain this in the following pages, and in passing take a quick look at how color has been thought about throughout the ages, before photography. One of the true benefits of digital photography and digital processing is that we can now take this deeper look at color. And in fact, we ought to.

How color affects the viewer—your viewers, the people who are going to look at your images—is now highly practical. Two developments in digital photography illustrate the new ways of thinking about color that have already entered photography: the color circle and RGB. The color circle as a way of displaying pure hues has a long history, and it's far from theoretical. Now, along with color-space models, it is familiar to anyone using Photoshop or Lightroom. It even makes an appearance in most digital cameras, when you adjust the hue. RGB is even more well known, because the camera's sensor, which records monochrome, is

filtered with a mosaic of these three colors, and the resulting image is a combination of these three as channels. Digitally, when processing and later, you can actually take these apart and make adjustments.

In this first chapter we'll see not only this, but look at the individual colors themselves and the fundamental differences between the digital primaries (RGB) and the painting primaries (RYB). The visual power of red, the brilliance of yellow, or the coolness of blue all present different factors for consideration. The better you understand the psychological response to color, both overt and hidden, the better you'll be able to take advantage of it in your images.

SIMPLICITY

When the feature you want to be the focus in a picture is variously colored or patterned, like this headscarf worn by a young Dinka woman in Southern Sudan, sometimes keeping it simple results in a stronger image.

Color Theory, Color Practice

Our response to colors is complex, involving reactions at an emotional, subjective level to the physical facts of light at different wavelengths.

Used well, color can be by far the most powerful element in a photograph. If it strikes a sympathetic chord in the viewer, it can be the very essence of the image. In this, it differs from other graphic elements. The arrangement of lines, for instance, may create a sensation of movement or stability, but color invokes responses at different levels, including some that are not always possible to describe accurately. Nevertheless, the difficulty of finding an exact terminology does not lessen the importance of what Gauguin called the "inner force" of color. It is often more appropriate to say that we *experience*, rather than simply *see*, a color.

The physicist James Clerk Maxwell, in 1872, determined that the human eye distinguishes color by responding to three different stimuli, the so-called tristimulus response that is very closely related to the way in which digital cameras and computer monitors work. He wrote: "We are capable of feeling three different color sensations.

Light of different kinds excites these sensations in different proportions, and it is by the different combinations of these three primary sensations that all the varieties of visible color are produced." In fact, the three stimuli are three different pigments in the cones of the retina—erythrolabe, chlorolabe, and rhodopsin—which are sensitive to red, green, and blue light.

This discovery had major implications, not only for the recording and display of

The multilevel sensation of color

Our ultimate response to color depends on a mixture of the physical, physiological, and psychological components. Color is wavelength and measurable scientifically (see page 26). It is then processed by the eye-brain combination, beginning with the retina. Finally, the brain relates this stimulus to its own experience, which can involve associations as varied as emotion, preference, and symbolism.

THE EYE AND PERCEPTION
The lens focuses an image, with the iris helping to control the amount of light entering. The retina contains a mixture of rods and cones, the former sensitive to low light but monochrome, the latter needing more light but sensitive to color. The fovea has the highest concentration for high resolution.

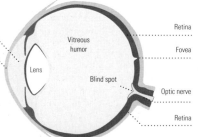

Iris

Cornea

Retina

Vitreous humor

Fovea

Lens

Blind spot

Optic nerve

Retina

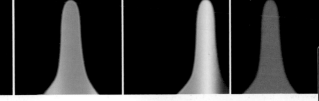

COMBINED SENSITIVITY

Above: Adding the three kinds of cone together gives spectral vision that is clearly weighted toward green, but the addition of rod sensitivity gives an even spread.

TRICOLOR SENSITIVITY

Right: Like a sensor, there are three types of cone, each sensitive to a different wavelength. Note that the red-sensitive cones actually peak in yellow. Scotopic, monochrome vision, peaks in between blue and green. These charts show the wavelength response of the green-sensitive cones, blue-sensitive cones, red-sensitive cones, and scotopic vision (rods).

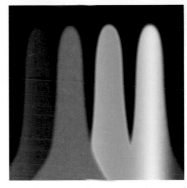

color—digital sensors, film, and computer monitors work using much the same principle as the eye—but on the fundamental idea that all colors can be created by mixing three. Painters had already come to that conclusion, though with different hues, and all this lent a special force to the concept of basic colors, the ones that can be used as building blocks to make others. Here is a case where physical fact transforms into color aesthetics, and for much of this chapter we'll look at color through its basic perceptual hues. The starting point is the palette of pure colors.

Most of the theory of color aesthetics has been developed with painters in mind, and for the most part has only vaguely been applied to photography. I shall attempt to redress this balance a little in the following pages. The usefulness of studying color theory for a photographer is that it will refine your discrimination and judgment. It is too easy to evaluate colors

and color relationships on the simple, subjective grounds of "like" or "don't like." Certainly, most people do judge color in this way, but this is analogous to enjoying music without having any musical training; while the lack does not inhibit the pleasure of listening, a study of music will definitely enhance it. Moreover, if, as a photographer, you want to become skilled in creating powerful color effects, the theory of color will certainly give you the means. Although color provokes a subjective response in a viewer, it does obey definite laws; we will see this in a few pages when we consider relationships between colors. The principle of harmony is not only a matter of whether an effect seems pleasing or not, but also depends on the actual, physical relationships, and can be measured.

Color Models

An essential first step in describing and dealing with color is to measure it in a standard way—and there are several of these methods, each with its particular uses and each using three common parameters.

This is part of a terminology that has sprung up with digital imaging, but in fact color models evolved centuries ago. The first known color diagram is from the 15th century, but it was a scale of the different colors of urine for medical use. The scientific analysis of color and the creation of graphic models to represent it began in earnest after the publication of Isaac Newton's *Opticks* in 1702. His key discovery was that light contains a sequence of wavelengths that each have a specific color, which we will look at in more detail on page 26, but this has overshadowed two other important contributions. One was to arrange colors in a circle to show their relationships with each other, and that which followed from it: the notion of complementary colors, opposite each other on the circle, which mix to create a neutral. More of this in Chapter 3.

The earliest color models were circles, though other shapes were used, such as the triangle and linear scales. For considering hues these two-dimensional diagrams are adequate, but as the full range of color needs three parameters, the more complete color models are now usually represented as 3-D solids. As we will see in the next several pages, the most widely used and accepted set of parameters for defining color are hue, saturation, and brightness.

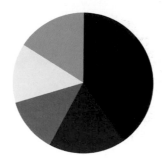

NEWTON'S CIRCLE
The spectral colors identified by Newton are those of the rainbow and are commonly described by seven names: red, orange, yellow, green, blue, indigo, and violet. All of these can be laid out in a continuous progressive sequence, but if this sequence is arranged as a circle, as Newton did, the relationships between all the hues become clearer. The circle is also a great help in understanding the reasons for color harmony and balance. It is the basic tool of color theory. Newton described the colors in his book, rather than showing them, and they have been interpreted here. With seven identified hues, it is, of course, asymmetrical.

Considering just the color circle and hue—the essence of color—there is a conflict between those models based on reflected light and those based on transmitted light. We will keep returning to this issue, because it causes problems with identifying primary colors (page 16) and complementary relationships (page 104). When Newton began the debate with his splitting of the prism and his color circle, he was showing spectral colors, while most other color theorists worked, quite reasonably enough, with pigments that are seen by reflected light. In digital

THE SPECTRAL CIRCLE

The color spectrum is in fact continuous, one hue blending into the next. Here it is arranged as a circle and rotated so that red (0° in the usual notation of hues) is at the top

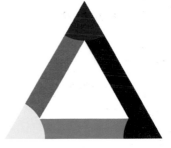

THE COLOR TRIANGLE OF DELACROIX

The French painter Delacroix constructed a triangle with arcs of primary colors at each apex, connected by the secondaries.

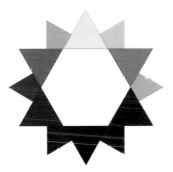

BLANC'S COLOR STAR

A color star by Charles Blanc developed in 1867 uses conventional primary and secondary colors, but the tertiaries have some pretty exotic names.

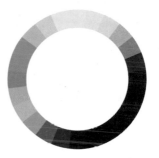

OSTWALD'S CIRCLE

The German chemist Wilhelm Ostwald in 1916 produced a 24-part circle based on the four perceptual primaries: red, yellow, blue, and green. Edward Hering had argued, like Mondrian, that green was perceptually basic.

photography we use both systems—transmitted light for viewing on the monitor and reflected light for prints—so we cannot escape the conflict. This is examined in more detail on the following pages, but basically, not only are the hues somewhat different between the two systems, but they are viewed in completely different circumstances so that there is no common ground for comparing them. The spectral color circle of Newton printed here is only an approximation, as it is impossible to reproduce accurately on paper with printing inks.

As color models developed, they took into account the ways in which colors are modulated to be brighter or darker and to be more or less saturated. Painters could achieve all of this modulation with black and white pigments (or with complementaries), which is why it took some time to arrive at a full understanding of the three axes of color—hue, saturation, and brightness. Reproducing these made a three-dimensional solid necessary, and the first was that created by Albert Munsell.

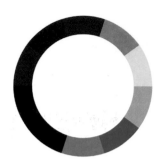

THE MUNSELL CIRCLE

The American painter Albert Munsell published in 1905 his color model that was to become the standard for colorimetry, and is used to this day in GretagMacbeth/ X-Rite charts. It is based on five principal colors—red, yellow, green, blue, and purple—and five intermediates, all finally sub-divided into 100. This circle was the basis of the more valuable solid (see below).

THE MUNSELL TREE

In Munsell's 3-D solid, chroma runs around the circumference, with a scale of desaturation inward toward the center and a polar axis from black to white. But because maximum saturation (chroma) is reached at different levels of brightness by different hues, the final shape is asymmetrical and so often represented, as here, as a tree. Here, Munsell's steps have been replaced by continuous tone.

ITTEN'S CIRCLE AND TRIANGLE

The color circle of Johannes Itten at the Bauhaus also begins with red, yellow, and blue. With the secondaries and tertiaries this divides into 12 parts. The color triangle is derived from this, although the tertiaries are necessarily different.

L*A*B*

CIE Lab (strictly speaking, L*a*b*), was developed in 1976 by the Commission Internationale d'Eclairage, designed to match human perception as closely as possible. It uses hue, saturation, and brightness along three axes, and digitally these are three separate channels, which can be accessed in Photoshop. Significantly, it is a very large color space, and so is a useful theoretical model that can contain most other models. One axis/channel is L* representing luminance (that is, brightness), a second is a* for a red-green scale, and the third b* for a blue-yellow scale. The principle is that red cannot contain green (nor vice versa) and blue cannot contain yellow (nor vice versa). Shown here are a circular cross-section and a cross-section through the 3-D solid. This latter cross-section represents the spectral color gamut with a characteristically asymmetrical shape due to the human eye's extended sensitivity toward green. We will see this shape later when we look at color spaces and gamuts (page 80).

PRIMARY COLORS

Red, green, and blue are the primary colors of the digital age, while red, yellow, and blue mix to form most other shades for the painter.

Primary Hues

A few pure hues are considered to be the basic colors from which all others are derived, yet there have been different versions of exactly what these are.

The idea of primary colors is an old one, dating back many centuries, but it has not always meant the same thing. In one sense it means a core of the most important colors, but added to this is the concept of irreducible hues from which all others can be created. These two are not necessarily the same. Most of us are now familiar with the idea of digital color being made up from red, green, and blue, but this is a relatively recent concept. As the color historian John Gage notes, anthropological studies of language have revealed "the much older and more universal set, black, white, and red," because "the earliest color-categories were those of light and dark, followed almost universally by a term for 'red.'"

Before the idea of mixing colors entered the scene as a way of defining primaries, they were identified by different processes, some intuitive, others related to the materials. Theophrastus in the late 5th century reported that Democritus argued for four "simple" colors: black, white, red, and green. Aristotle identified five unmixed colors: crimson, violet, leek-green, deep blue, and either gray or white. In the Middle Ages, red, yellow, and blue were used not because they mixed to produce other colors, but because they were the three most prized color materials: vermilion, gold, and ultramarine. Moreover, some of the earliest notions of basic primaries linked them to fundamental concepts such as the four elements (earth, air, fire, water) and to the seasons. Even Leonardo da Vinci had views on this.

With the development of sophisticated oil painting techniques in the 16th century, the mixing of pigments to create new colors became more important. Pigments had, of course, been mixed for as long as man painted (the oldest known artifact is a quarter-

AN ANCIENT PRIMARY
Throughout history, the range of hues between red and orange have been considered the strongest, the most "colorful," and feature prominently in numerous religions. In Indian mythology red symbolizes, among other things, female power—a suitable backdrop to these bronze statues of the goddess Devi.

COLOR CUBE

Hue is one of three qualities of color that can be measured in the Hue Saturation Brightness (HSB) model. One illustration of the relationship is a cube, shown here with hue changing horizontally across the left face, saturation horizontally across the right face, and brightness vertically across both from a black base to a white top.

million-year-old mortar used for this purpose), but now the theorists began to take part. Agreement gradually settled through experiment on the three colors red, yellow, and blue as what became known as the "painters' primaries," and these remain valid today, even though they are clearly apart from the RGB used in digital imaging. There is a major difference in the way colors can be mixed between physical pigments like paint, and light. Mixing physical painters' primaries is intuitive and seems natural, while mixing colored light produces different results that are not intuitive. Red and green, for example, produce yellow, which is not what the eye expects. This method of mixing is how digital cameras, monitor screens, color film and, incidentally, our retinas work, which makes it highly relevant for photography, but it is at odds with the mixing of pigment on paper. Instead of red, yellow, and blue, the three primaries for transmitted light are red, green, and blue. This fact became known well before colored lights could be projected by the trick of spinning a disk on which colors were painted. However, a comparison between the

Hue

The fundamental quality of color is hue. Hue is very much the prime quality of a color, and is what gives the color its uniqueness. When most people refer to "color," they usually have in mind the hue—the quality that differentiates red from blue from yellow, and so on. In fact, we prefer to give names to colors than to give qualified descriptions. "Crimson" sounds more precise and identifiable, for instance, than "red with a touch of magenta," and "ocher" a more natural definition than "dark yellow."

two systems, reflected and transmitted, is impossible to reproduce accurately in any one medium, and here on the page the reflected colors print the more accurately. The transmitted primaries RGB are spectral, and for true accuracy you should view them on your monitor—they look brighter and more intense than their equivalents on paper.

Thus there is no simple way to square these two primary systems with each other; each is perfectly valid. Moreover, it is not just a matter of physics—reflected light versus transmitted light—because of the psychological component of color. Colors are primary not only in the sense that they can be mixed to create all others, but also in that we perceive them to be in some way basic and important. The reflected and transmitted primaries have red and blue in common (with the proviso that they are not the same between the two systems), and differ in yellow and green. Yet, on psychological and cultural grounds, neither yellow nor green can be ignored, and this argues for four primaries. Indeed, the painter Mondrian argued for these four instead of the more usual three.

My solution at this point of the book is to consider red, yellow, blue, and green as the most important perceptual primaries but, so as not to offend purists, everything is arranged in the traditional order of painters' primaries and secondaries. We are, after all, in this first chapter introducing

RGB VERSUS CMY

Although red, yellow, and blue have been established for centuries as the "painters' primaries," cyan, magenta, and yellow are perhaps more recognizable as subtractive "photographic primaries." These are the standard colors used in color printing, be it filtration in a photographic enlarger, or the inks used in a printing press or desktop printer (here with the addition of a black "Key" to make CMYK). Like the RYB painting primaries, CMY inks combine to create near-black when all three are superimposed. The equivalent mixture for the three transmitted-light primaries—red, green, and blue—is by projection, and they combine quite differently, with white as the result of all three together.

colors as they appear and with their associations. Making and manipulating colors digitally is another matter for a later chapter. Before experimenting with the ways in which colors combine, we'll take a long look at each of the principal hues, one by one. The three or four primaries and the secondaries have distinct characteristics, and understanding the personality of each lays the foundation for appreciating the wide range of color relationships.

DIFFERENT IDEAS OF PRIMARY COLORS

To illustrate the diversity of opinion over what the most basic and most important colors are, the following sets have all been considered primary.

Black, white, and red is the most ancient and primitive set, revealed by color linguistics.

Red, yellow, and blue had by the 17th century become accepted as the three painters' primaries (black and white being treated as modulating the color).

Black, white, yellow, and red was Pliny the Elder's view in the 1st century.

For Mondrian, green needed to be added to the three-color set, to give red, yellow, blue, and green.

Aristotle identified five colors, which he named crimson, violet, leek-green, deep blue, and gray/yellow.

Red, green, and blue are the spectral primaries used in sensors, film, and computer monitors—that is the primaries of transmitted rather than reflected light.

Black, white, red, and blue were listed by the French philosopher Louis de Montjosieu in 1585.

Cyan, magenta, yellow, and black are the four primary colors used by printing presses for books, magazines, and similar printed material. They also form the basic inkset used by most inkjet printers.

Saturation

Pure hues are fully saturated, meaning that they are at full intensity, while most of the colors that we meet in life are a lower percentage than this, all the way down to a completely desaturated gray.

Hue, as we just saw, is the first parameter of color according to the way we perceive it. The others are saturation and brightness, and both are modulations of hue. Saturation, also known as chroma, is a variation in the purity of a color, its intensity or richness. At one end of the scale are the pure, intense colors of the color circle. As they become less saturated, they become more gray, "muddier," "dirtier," and less "colorful." In the physical world, rather than the digital

photographic one, pigments, dyes, and paints become unsaturated when they are mixed with white, black, gray or their opposite colors on the color circle, which are known as complementaries. The primary hues that we saw on the previous pages, and most colors that we describe without qualification (such as "blue" rather than "cobalt blue") are fully saturated, and any variations are in one direction only— toward gray. In nature, particularly on the grander scale of landscapes or panoramas, most colors are unsaturated.

Most photographic subjects are things that photographers discover, rather than build themselves, so adulterated or broken

NATURE'S LESS-THAN-SATURATED COLORS

Below: Fully saturated colors are rare in nature, and tend to be very localized, as in flowers and the pigmentation of some animals. Even what we might react to as a strong blue sky is, in reality, quite adulterated. The scene here, from an altitude of 16,500 feet (5,000m) in

the Tibetan Himalayas, illustrates the point. The clarity of the atmosphere and the altitude intensify the colors, and they look strong without comparison. But seen in a schematic way as blocks of colors and compared with fully saturated hues, the reality is more moderate.

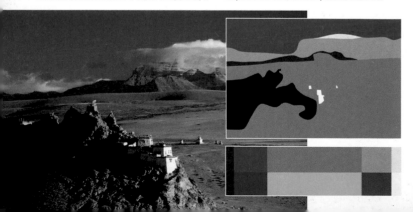

colors are the staple palette. In nature, grays, browns, and dull greens predominate, and it is for this reason that the occasional pure color is often prized and made the feature of a color photograph when found. Rich colors are therefore more often seen as desirable by the majority of photographers than are pastel shades. There is no judgment intended here—rich combinations and pale combinations can make equally powerful images—but it goes some way to explaining the attraction of intense colors. If they were a more dominant component of the landscape, more photographers would perhaps be drawn toward the subtler shades.

BRIGHTNESS

Above: As these two cross-sections of an HBS (HVC) solid show, different hues show maximum saturation at different levels of brightness. Thus yellow is most saturated when brighter than, say, purple.

HUE

Right: Hue, brightness (value), and saturation (chroma) each occupy an axis perpendicular to the others, to give a 3-D model. It is easy to see from this why hue is measured as an angle from 0° to 360°.

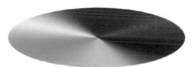

SATURATION

Left: On this image of ancient pyramids in Sudan, a range of saturation has been applied from left (completely desaturated) to right (double the normal saturation). Choosing the appropriate level is not as easy as it might at first seem.

Brightness

The second modulation of hue is how bright or dark it is, and the maximum brightness depends on the precise hue, with yellow the highest and violet the lowest.

Brightness, also known as brilliance and value, is the lightness or darkness of a color; white and black are the extremes of this scale. It is sometimes a little difficult to distinguish brightness from saturation, but it may help to remember that, in varieties of brightness, the color remains pure and unadulterated.

The actual range of lightness and darkness differs between hues, and this can cause difficulties in matching the

brilliance. Yellow can only vary between a medium tone and very light; there is no such thing as a dark pure yellow. Red, as you can see from the scale on the next page, becomes pink when very light, and so loses its main qualities. Blue, however, covers the full range. Orange, because of its closeness to yellow, does not have dark pure versions, but the range of greens is affected more by the blue component than by the yellow, and can be very light or quite dark. Violet changes its character at either end of the scale, becoming lavender when light, but hard to distinguish from deep blue when dark.

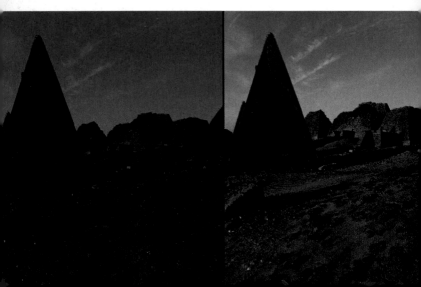

Yellow green	"Lemon"	Yellow	"Golden"	Yellow orange

A VERY LIMITED HUE

Above. With pure yellow in the center, this space moves left toward green and right toward orange. Only personal taste can set these limits, but for most people yellow quickly turns into green on the one side and orange on the other. Most people have little tolerance for a contaminated yellow.

ALTERING BRIGHTNESS WITH LIGHT LEVEL

Left & right. As shown in the progressive steps of this sequence, slight underexposure increases the intensity of hues while significant underexposure simply darkens them toward black. Overexposure reduces the primary characteristics of hue, creating paler and paler tones.

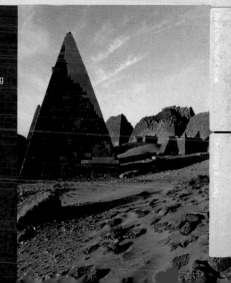

Brightness depends very much on the light level, and in photography is the one quality that can be changed most easily, by varying the exposure. Test this for yourself by photographing any scene that has a strong color, and bracket the exposures over a range of several stops. The result will be a very accurately graduated scale of brilliance.

BRIGHTNESS VARIATION

Below: A comparison of brightness value (from minimum at the left to maximum at the right). The hue value for the three primaries remains constant.

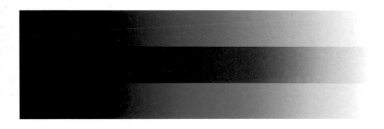

Color and light source

Because of differences in color temperature between light sources (see pages 28–9), some colors vary in their apparent brightness. Blue, for example, appears darker under blue-deficient tungsten light and the broken spectrum of most fluorescent strips.

Sunlight	Incandescent lighting	Fluorescent lighting

BRIGHTNESS AND HUE

Right: As we saw on page 21, the effect of brightness (value) varies according to the hue. Yellow, in other words, is always bright, becoming an ocher when darker, while purple is always dark, becoming mauve when pale. This is represented graphically in these two cross-sections of an HSB solid. Brightness is the vertical axis, saturation the horizontal, demonstrating that fully saturated yellow is brighter than fully saturated purple.

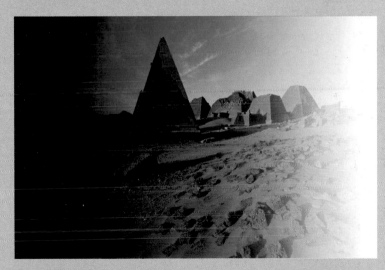

BRIGHTNESS CHANGE ONLY

Above: Returning to the pyramid scene, its brightness alone has been altered from minimum at left (black) to maximum at right (white). Compared with the saturation variation, finding the best point along the scale is easier, but it is still flexible

The Color of Light

The first part of the color equation is the wavelength of the light source—be it the sun, camera flash unit, or tungsten lamp—and it varies the whole breadth of the spectrum.

The phenomenon of color is an interaction between light and surfaces. This is true of anything visible. Light of a certain color falls on an object that itself has a particular color. What is reflected (or, in the case of something transparent, transmitted) to our eyes is a combination of the two. In the case of digital photography in particular, this is not just an academic distinction.

Color exists and functions at different levels, as already described, but it is at its most measurable and objective as a wavelength of light. Light fits in to a very small part of the electromagnetic spectrum, which includes X-rays, infrared, radio waves, and other wavelengths, some of which are in one way or another important for us. This spectrum is continuous, between short and long, and the only thing that sets light apart from the rest

The eye and color

The human eye is more or less sensitive to different wavelengths, and as you might expect is most sensitive to those in the middle, around yellow-green. For this reason, yellow is for us always a bright color, while violet is always dark—explored in detail on the following pages. There is also a difference in the eye's spectral sensitivity between dark and light. We see color through the cones in the retina—the eye's photopic system—but at low light levels the color-insensitive rods take over—the scotopic system. As the diagrams here show, the two systems peak at different wavelengths.

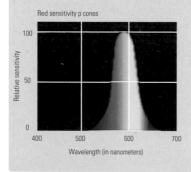

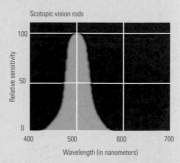

Colors in the electromagnetic spectrum

The electromagnetic spectrum is infinite, but even the "useful" range for us, from X-rays and gamma rays to long-wave radio, is many times larger than the visible spectrum, from about 400nm to about 700nm.

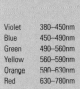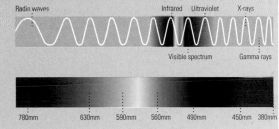

Violet	380–450nm
Blue	450–490nm
Green	490–560nm
Yellow	560–590nm
Orange	590–630nm
Red	630–780nm

Radio waves · Infrared · Ultraviolet · X-rays · Visible spectrum · Gamma rays

780mm · 630mm · 590mm · 560mm · 490mm · 450mm · 380mm

is that we can see it. In other words, we make up our own definition for it. As Sir Isaac Newton determined in 1666 when he analyzed the visible spectrum with a prism, our eyes identify each wavelength in the narrow band between about 400 and 700 nanometers (nm) or millimicrons (10-9 meter or 1/1,000,000mm) with a particular color for which we have a name. Traditionally (but it is only tradition), there are seven distinguishable colors in this spectrum, which in nature occurs most recognizably in a rainbow—violet, indigo, blue, green, yellow, orange, red. Nowadays it is more usual to divide the spectrum into six named segments, omitting indigo. Seen all together they appear as white, which is exactly the light we live by most of the time, from the sun when it is well above the horizon. There's no mystery in this. Our eyes evolved under sunlight and our brains treat it as normal—basic, colorless lighting. And, as you already know from using the white balance menu

in a digital camera, this is a practical, not a theoretical, matter.

The shortest wavelength that most people can see is violet, and the longest is red, and the fact that deep violet and far red appear to our eyes as very similar makes it possible to arrange all these colors conveniently in a circle, which we saw on page 12, but it's worth remembering this is just a construct. Violet at 380–450nm and red at 630–780nm don't actually "meet;" they continue in opposite directions into ultra violet and infra-red. Interestingly, unlike our other sense organs, our eyes cannot discriminate between the wavelengths—colors—in a mixture. We simply see a mix of wavelengths as one color. When all the wavelengths are present we see them as white, while a sunset mix from, say, 570nm to 620nm we see as "orange-red."

Color Temperature

A measure of the warm or cool appearance of a light source, color temperature has lost much of its importance with the arrival of digital photography.

An entry on color temperature is mandatory for any technical book on photography, but I can't help thinking that it has become over-worked. The technical details are covered here in the box, but its usefulness in the real world of photography is, in these digital days, mainly as a guide to the change in the color of daylight at different times of day. The ubiquitous white balance control in cameras and software has some relation to it, but despite the fact that you now have opportunities to drag sliders across color temperature scales marked in degrees Kelvin, it is less relevant to digital than to film photography.

This doesn't sound quite right, does it? After all the effort matching Wratten filters to light sources and choosing between daylight, Type B, and Type A film, digital suddenly offers complete control—and yet it isn't as important. The thing about color temperature is that it is a scientific measure that was co-opted by photography, mainly because it could handle the differences between sunlight and incandescent lamps (both sources burn and so they are on the same scale). Everything else, such as blue skylight and fluorescent lamps, was simply fitted in with greater or lesser accuracy. In fact, fluorescent lamps and vapor discharge lamps are not on the color temperature scale. Ultimately, the goal is to be able to choose the color of the light as it appears in the image, and it does not matter whether the source is incandescent, reflections from other surfaces, photoluminescent, or vapor discharge.

Color temperature

The scale of color temperature, from amber to bluish, is based on the color that an object would glow if heated up to various temperatures. For consistency, the actual makeup of the substance is ignored, and is treated theoretically as a "black body." Measured in degrees Kelvin, it has a special relevance to photography because most of the important light sources used for shooting lie on it. Heated beyond 1000K, a substance begins to emit light, but very red. Heating it more makes it glow whiter, and at 5800K, the temperature of the surface of the sun, the color is exactly neutral white. Heated more than this, the color becomes increasingly blue. Although the contrast between the two ends of the scale does not correspond exactly with the red-orange/blue-green contrast shown on pages 122–25, it is a fairly close match, and can be made use of quite easily, as the examples on these pages show.

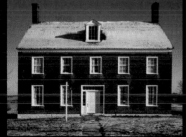

EVENING WINDOWS

Top: With a daylight-balanced setting, the orange lights of this Bangkok home contrast with the rising color temperature of evening light after sunset.

SHADOWS ON SNOW

Above left & right: A Shaker building in Kentucky on a bright winter's morning shows the unexpectedly blue cast of shadows on fresh snow.

The Broken Spectrum

The light from fluorescent and gas discharge lamps often appears more strongly colored in photographs than it looks to the eye, and needs special white-balance treatment.

Two of the most efficient artificial light sources, used increasingly in interiors and outside at night, are gas discharge (sodium, mercury, and xenon) lamps and fluorescent. Gas or vapor discharge lamps work by passing an electric current through a particular gas, usually at a low density. Fluorescent lamps are, in effect, mercury lamps coated on the inside of the glass with phosphors—these are substances that absorb and then re-emit light. By adjusting the composition of the phosphors, lamp manufacturers can create different colors of light.

The problem for photography with these light sources is that they do not contain the entire spectrum, yet the eye is able to accommodate this deficiency. The camera sensor, however, captures their light as it really is, often with a distinct color cast. In film photography this could be corrected only by filters, but not always fully. Digitally, the white balance setting can cope with most of them, and further correction is possible later. In particular, most fluorescent lights are "seen" as white whereas, in reality, the individual phosphors glow at distinct and different wavelengths. Their spectrum has gaps and spikes.

This seems, on the face of it, paradoxical. Why should the eye register this kind of lighting differently from a camera's sensor—or film for that matter? The reason is that the eye cannot differentiate between the different wavelengths making up the total color experience. A trained ear can separate the several instruments in an orchestral work, and a trained palate the individual flavors in a dish, but even with experience there is no way to educate the eye to see the

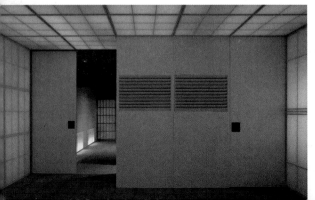

SUBDUED LIGHTING

A combination of concealed adjustable fluorescent striplights and daylight provide soft, even lighting from ceiling and walls— appropriate for a room in which trainee Zen monks meditate.

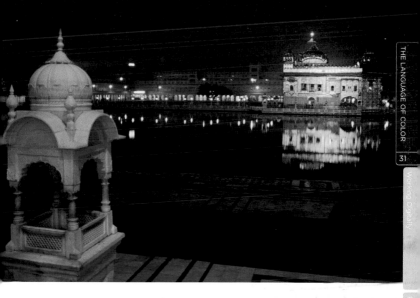

components. This is an advantage with broken-spectrum lighting because, whatever the gaps, it is still possible to create the effect of white. Captured by a sensor, or by film for that matter, the light from most fluorescent lamps is bluish-greenish and, for various psychological reasons, a greenish color cast is thought of as unattractive by most people.

The basic correction is performed in the camera from the white balance menu, where there are, depending on the make of camera, one or more settings for fluorescent light. These can often be further adjusted by a few degrees of hue. Alternatives are to use the automatic setting (particularly valuable if the fluorescent lamps are mixed with daylight, tungsten, or other sources), or to create a special preset white balance by taking a

MIXED

At Amritsar's Golden Temple, the perimeter buildings around the lake are lit by mercury-vapor lamps. The contrast with the incandescent lighting on the Golden Temple itself makes a positive contribution to the image.

reading from a sheet of white paper (the procedure varies according to the camera).

As for gas discharge lighting, there may be no complete correction possible because some wavelengths are missing. This is certainly the case with sodium lamps, commonly used in street lighting and floodlighting, which looks yellow and lacks blue. Often the best result that can be acheived with this digitally is to go for a desaturated, almost monochrome, look.

The Color of Objects

The second element in the equation of color is the surface struck by the light. According to its composition, it can reflect, transmit, and absorb the light selectively, and thus give an object "color."

Leaves are green, Caucasian flesh is pinkish, a marigold is orange, and we know these are intrinsic properties of the things themselves. This is common sense, but has implications that are easily overlooked in digital photography when color is being adjusted. The final color that we see, and that the camera records, depends not only on the light source but also on the surface it strikes. Because the menu settings on digital cameras place so much emphasis on measuring the color of light and adjusting the sensor's response to it through the white balance, it's easy to overlook the contribution of the objects in the scene.

A coat of glossy white paint reflects a high proportion of the light, transmits none (it is opaque), and absorbs very little. Most of the light, therefore, is reflected right back. A piece of black cotton velvet, by contrast, reflects hardly any light, transmits none, and absorbs most of it. This seems blindingly obvious because of the way we describe objects and surfaces. However, with the exception of white, black, and gray objects, every other surface reacts to light selectively, meaning that it favors some wavelengths—colors—more than others. Reflection and absorption work together inversely. Most fresh leaves are green because they absorb so much red. A daffodil appears yellow because its petals absorb blue.

Transparent materials transmit more light than they reflect or absorb, and when they do this selectively (like the acetate in 3D glasses) they appear colored. Moreover, the effect builds up with depth-normal glass absorbs a little red, so thick slabs take on a greenish tinge, while water absorbs first red, then yellow, and continues until, far below the surface, the color is simply blue. This effect is well known to underwater photographers, who need flash to restore the lost colors. Seawater cupped in your hand seems colorless, but 30 clear feet (ten meters) of it over white sand, seen from above, appears a strong blue.

COLOR WITH DEPTH

Above: An aerial view of shallow waters off an island in the Philippines illustrates clearly how increasing depth (here from the bottom to the top of the image) renders the appearance of seawater first green, then blue.

COLORED GLASS

Opposite: Colored glass has a long history in decoration, and not just in Christian church windows.

Refraction and color

Refractive Index (RI) is the ratio between the speed of light in a vacuum (such as the sun's light reaching Earth), and the slower speed in a transparent substance (air, glass, water, for example). The higher the RI, the more light is slowed down, and if the light strikes the surface at an angle, it changes direction— the basis of lens optics. From the point of view of color, RI is important because it is different for different wavelengths. It is lower for long wavelengths like red and higher for short ones. Prisms and raindrops, for example, break up the spectrum because of this.

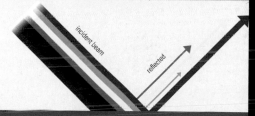

incident beam

reflected

absorbed

Red

Red is one of the most insistent, powerful colors, and immediately attracts attention, in addition to having many strong associations.

When set against cooler colors, greens and blues in particular, red advances toward the viewer, meaning that it seems to be in front of the other colors and, under the right conditions of subject and color intensity, can bring a genuinely perceptible 3-D effect. It has considerable kinetic energy, and produces some of the strongest vibration effects against other colors.

In contrast to the transparency and luminosity of yellow, red is relatively dense and solid. In terms of its characteristic of

REDS

FIREBRICK

BROWN

DARK SALMON

SALMON

LIGHT SALMON

ORANGE

DARK ORANGE

CORAL

LIGHT CORAL

TOMATO

ORANGE RED

RED

HOT PINK

DEEP PINK

PINK

LIGHT PINK

PALE VIOLET RED

MAROON

MEDIUM VIOLET RED

VIOLET RED

RED PAINT

Below: Along the northeastern coast of North America, for some reason red has long been a favored color for timbered barns and other buildings. This striking example is in New Brunswick, Canada.

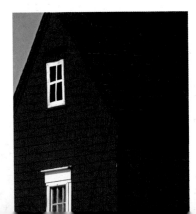

TELEPHONE BOXES

Above: Red telephone boxes along with mailboxes (postboxes) are a significant cultural icon of British streets.

TILAK

Below: The red dot painted in the center of the forehead in India is so widely used that mounds of the red powder are a common sight in markets all over the country.

redness, it has considerable latitude; in other words, it can move a way toward orange or toward violet and still be seen as essentially the same color: red. While yellow can be felt to radiate light, red radiates the most energy. Emotionally, red is vital, earthy, strong, and warm—even hot. By extension, red can connote passion (hot-bloodedness) in one direction and, in the other, the infernal, aggressive, and dangerous. If we add the association with blood, there are then also connotations of warfare and fiery destruction. The temperature associations have obvious origins, and indeed red is commonly used as the symbol for heat. Perceived as a very powerful color, it is a symbol for warning and prohibition, such as to indicate "stop" at traffic lights. Red has also, from its

expressive associations with blood and war, been a symbol of political revolution. During the Chinese Cultural Revolution some traffic lights were left unused because of the conflict between its prohibitive and revolutionary meanings! In Suprematist Russian painting in the 1920s, red stood for revolution as an intermediary color in a sequence that began with black and ended with white for pure action. From the perspective of celebrity culture, red acknowledges power too—what award ceremony would be complete without a red carpet?

An essential indicator is, as always, how most people refer to a particular color and, among all the hues, red seems to cause less confusion across cultures and time than others (see pages 12–15 for the confusion of blue with green). At the far end of its bluish range, it produces a variety of exotic hues, including magenta and purple. Even when adulterated toward russet, and when dark, red remains recognizable.

Red is fairly abundant for photography. It is relatively popular as a paint finish on buildings, vehicles, and signs. In nature, many flowers are red, and display interesting varieties of hue. Indeed in nature red is often associated with warning too—poisonous animals advertise their danger to predators via the color. Embers and other burning things glow red at a certain temperature, and the richest of sunsets and sunrises—when the sun is extremely low—are red, lighting clouds to the same color.

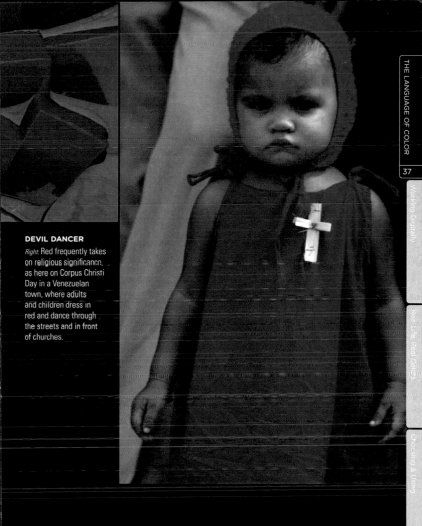

DEVIL DANCER

Right: Red frequently takes on religious significance, as here on Corpus Christi Day in a Venezuelan town, where adults and children dress in red and dance through the streets and in front of churches.

Yellow

Yellow is the brightest and lightest of all colors, and this brilliance is its most noticeable characteristic, which accounts for the way it is used practically and thought of symbolically.

Indeed, yellow does not exist in a dark form—if it is degraded with black, it simply becomes an earth color between brownish and greenish, but a dark yellow is still brilliant in comparison with all other colors. As it is most often found set against darker tones, yellow seems to radiate light in a picture. Matching its brilliance with

YELLOWS

PALE GOLDENROD

LIGHT GOLDENROD YELLOW

LIGHT YELLOW

YELLOW

GOLD

LIGHT GOLDENROD

GOLDENROD

DARK GOLDENROD

Yellow's variable energy

As the color squares demonstrate, a bright color like yellow receives energy from a dark setting, but is drained by a pale one. The central yellow square is identical in each. Far from being an exercise in optics, this has a real impact on photographing yellow. The yellow of the oil in the flask is actually more saturated than the aspen leaves, but the shadowed slope behind the trees on a Colorado hillside makes them seem distinctly more colorful and intense. Both oil and leaves are backlit and so show the full color without being diluted by surface reflections.

other colors is difficult: a similar blue, for example, would have to be quite pale. There is very little latitude in yellow; to be pure it must be an exact hue, while even a slight tendency toward yellow-green is obvious. All colors have a tendency to change character when seen against other colors, but yellow is particularly susceptible, as the photographs here illustrate. It is most intense against black, and most insipid against white. Out of orange and red it extends the spectrum in the direction of brightness. Against violet and blue it has a strong contrast.

Expressively, yellow is vigorous and sharp, the opposite of placid and restful. Probably helped by association with lemons

HONG KONG APARTMENT

In Chinese culture the color yellow corresponds with the element earth, and symbolizes, among other things, stability. It's also a highly revered color, with many royal associations.

(a commonly perceived form of yellow), it can even be thought of as astringent, and would rarely be considered as a suitable setting for a food photograph, for example. Other associations are mainly either aggressive or cheerful.

There is no clear line separating the expressive and symbolic associations of yellow (this is true of most colors). Much of its vigor derives from the source of its

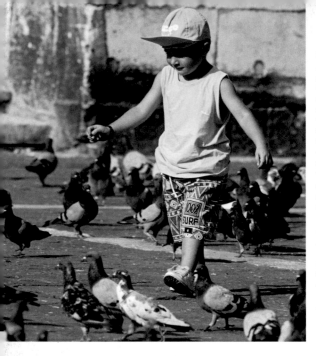

most widespread symbolism: the sun (which actually appears white until it's low enough in the sky for us to look at it without discomfort). By extension, yellow also symbolizes light. A second symbolic association with a very concrete base is gold, although yellow-orange is usually more appropriate.

In large-scale scenes like landscapes, pure yellow is not common, and tends to be found in specific objects. It tends to exist in smaller objects, like plants such as buttercups, marigolds, daffodils, and leaves, and fruits like lemon, melon, and star fruit. Egg yolks also put in an appearance. In the mineral world, sulfur is the strongest yellow, but is rarely seen, since it is most likely to be found in nature encrusted around volcanic vents. As a paint and tint for man-made objects, yellow has a special popularity when the idea is to catch attention, as in road warning signs, school buses in North America, mailboxes in Germany, and fishermen's waterproofs. It is also used just to be bright and cheerful.

When it becomes paler and less saturated, yellow begins to play a much larger role in scenes, most commonly because of the yellow component in morning and afternoon sunlight. The hazier the sunlight, because of dust or

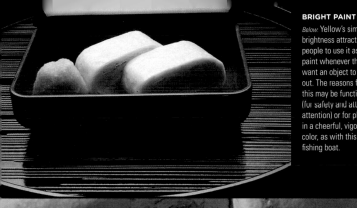

BRIGHT PAINT

Below: Yellow's simple brightness attracts people to use it as a paint whenever they want an object to stand out. The reasons for doing this may be functional (for safety and attracting attention) or for pleasure in a cheerful, vigorous color, as with this small fishing boat.

BATHED IN YELLOW

Above: Although pale, the yellow cast over this scene in a remote hill-tribe village on the Burmese border is unmistakable. The reason is the heavy burning of swiddened fields in the dry season before planting. This haze lowers the color temperature while the sun is still way above the horizon.

FLAME

Below: For the same reason that yellow is associated with the sun (incandescent light), it appears in the brighter part of flames, as in this Chinese temple. The hottest parts of the flame are both less red and brighter, and these two effects combine to make the centers of the tongues yellow.

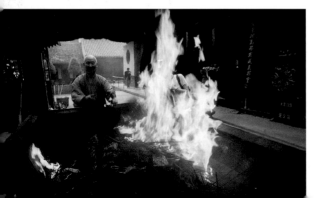

White balance & yellow

An American fire hydrant photographed late in the afternoon turns orange in the warmer light (left). Although by no means either wrong or objectionable, it does pose a problem: we know from experience that fire hydrants are less red than this, and while the effect is quite logical, some people might prefer to see the hydrant as remembered. Depending on taste, this may be a case for adjusting the white balance on the camera's menu.

particles in the atmosphere, the more it suffuses and, as the photograph taken in a hill-tribe village shows, it can at times bathe everything in a creamy, pale yellow light. Shooting into the sun emphasizes this, particularly with a telephoto lens which is allowed to flare.

Yellow's association with sunlight is no mystery – it is a color of heat, at least in its warmer, more golden tones. Look at the color temperature scale on page 28 and you'll see that pure yellow is not on it. However, in a photograph of flames, overexposed yellow-orange appears as a distinct, if slightly pale, yellow (and bright flames against a dark background acquire an extra impression of intensity). The same happens with ordinary domestic tungsten lighting and with candles. Yellow also appears in a very specific way in one kind of artificial lighting, sodium vapor. Here,

the broken spectrum (see pages 30–31) of the lighting records as a green-yellow.

One of the most interesting variations of yellow, which it shares with orange, is gold. As a metallic color, this is more fully explained on pages 154–55, and the key to photographing it is to capture the complex play of reflected light, shadow, and color across its surface. The color of gold varies with its purity, from high-carat yellow to low-carat copper-toned. In photographs of gold, yellow is usually found in the shiny highlight areas.

Blue

This is a quiet, relatively dark, and above all cool color, very common in photography and with a wide range of distinguishable varieties.

Blue recedes visually, being much quieter and less active than red. Of the three primaries it is the darkest color, and it has its greatest strength when deep. It has a transparency that contrasts with red's opacity. Although pure blue tends toward neither green nor violet, it has a considerable latitude, and is a hue that many people have difficulty in discriminating. Identifying a pure, exact blue is less easy than identifying red or yellow, particularly if there are no other varieties of blue adjacent for comparison. A valuable experiment is to shoot and then assemble a number of images, all of which were of things you considered to be "blue." The variations in hue are often a surprise; without color training, the eye tends to imagine that hues are closer to the standard of purity than they really are.

Expressively, blue is, above all, cool. Used in decoration, it even produces the sensation that the actual temperature is lower than it is. The contrast with red also occurs in other ways: blue has associations of intangibility and passivity. It suggests a withdrawn, reflective mood. The primary symbolism of blue derives from its two most widespread occurrences in nature: the sky and water. There are other, subjective, symbolisms; for example, the painter August Macke of Der Blaue Reiter (The Blue Rider, an expressionist group of the early 20th century) wrote: "Blue is the male principle, sharp and spiritual . . ."

BLUES

MIDNIGHT BLUE

NAVY BLUE

CORNFLOWER BLUE

DARK SLATE BLUE

SLATE BLUE

MEDIUM SLATE BLUE

LIGHT SLATE BLUE

MEDIUM BLUE

ROYAL BLUE

BLUE

DODGER BLUE

DEEP SKY BLUE

SKY BLUE

LIGHT SKY BLUE

STEEL BLUE

LIGHT STEEL BLUE

LIGHT BLUE

POWDER BLUE

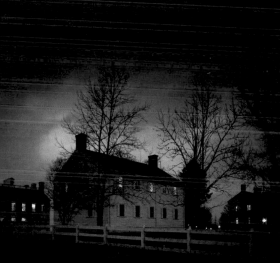

AERIAL

Above: A clear sky is the most accessible source of blue for photography, and is at its most intense at altitude—here a view of the Cascades mountain range in Washington State from an altitude of 30,000ft (9,000m).

DUSK

Left: One of photography's most common and reliable sources of blue occurs after sunset and before dawn, when the only source of daylight is what remains from the sky. Shot with a daylight white balance, a Kentucky Shaker village takes on an austere and cool appearance.

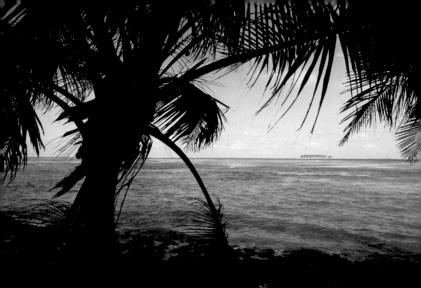

A TROPICAL BEACH

Above: A classic scene of palm trees overlooking shallow reefs in the Caribbean. Compare the color with that of the aerial view—seen from ground level, the water reflects the brighter, paler sky closer to the horizon. Pale green water in the distance is evidence of very shallow coral reefs.

Photographically, pure blue is one of the easiest colors to find, because of the scattering of short wavelengths by the atmosphere. The result of this is that a clear daytime sky is blue, as are its reflections (in the form of shadows and on the surface of the sea and lakes). Water absorbs colors selectively, beginning at the red end of the spectrum, so that underwater photographs in clear, deep conditions have a rich blue cast.

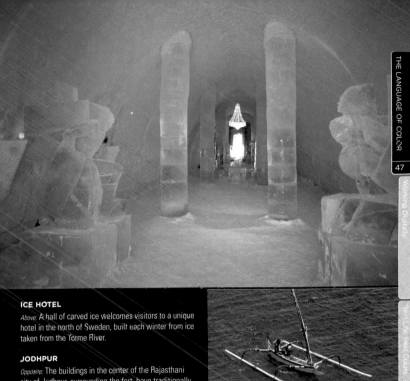

Real-Life Real Colors

Choosing & Using

ICE HOTEL

Above: A hall of carved ice welcomes visitors to a unique hotel in the north of Sweden, built each winter from ice taken from the Torne River.

JODHPUR

Opposite: The buildings in the center of the Rajasthani city of Jodhpur, surrounding the fort, have traditionally been painted this rich blue color, giving Jodhpur the name the Blue City.

THE DEEP BLUE SEA

Right: Three factors contribute to the rich blue of this aerial view of outriggers in the Philippines—clarity of the water, a cloudless, blue sky, and the angle at which it was shot (high, from a helicopter, with just the upper dome of the sky reflected).

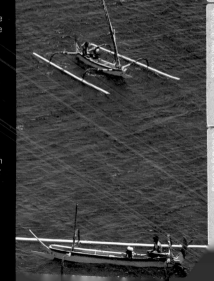

Green

The key color of nature, green is also the hue to which our eyes are most sensitive, and we can discriminate within it a large number of individual greens.

Between yellow and blue, green has the widest distinguishable range of effects of all the primary hues. It can take on many different forms—depending on how yellowish or bluish it is—and each with distinct characteristics. Although it has a medium brightness, green is the most visible of colors to the human eye: at low levels of illumination, we can see better by green light than by any other wavelength.

Green is the main color of nature, and its associations and symbolism, for the most part positive, derive principally from this. Plants are green, and so it is the color of growth; by extension it carries suggestions of hope and progress. For the same reasons, yellow-green has spring-like associations of youth. Symbolically, green is used for the same purposes as its expressive associations—youth and nature, with plant life in particular. For a more specific example, green signifies "go" at traffic lights, as opposed to the prohibition of the red "stop" light.

GREENS

DARK GREEN

DARK OLIVE GREEN

DARK SEA GREEN

SEA GREEN

MEDIUM SEA GREEN

LIGHT SEA GREEN

PALE GREEN

SPRING GREEN

LAWN GREEN

GREEN

CHARTREUSE

MEDIUM SPRING GREEN

GREEN YELLOW

LIME GREEN

YELLOW GREEN

FOREST GREEN

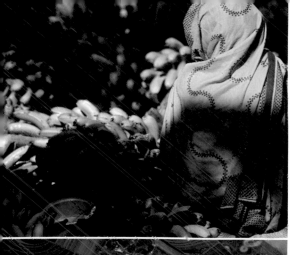

COMOROS MARKET

Left: In the morning market in Moroni, capital of the Comoros Islands—an Islamic republic—unripe bananas blend with the seller's green attire—green is the traditional color of Islam.

Working Digitally

MALACHITE

Left: The most intensely green of all rocks is malachite, which has an intense, even garish hue similar to viridian. Here it has been used for the surface of an inlaid table in a converted Indian palace.

Real Life, Real Colors

Choosing & Using

In nature, greens are very common. Pure green, however, is not easy to find, as you can see by taking a number of images in this color and comparing them with a standard reference. You can create one yourself to use as a digital color swatch on-screen, using Photoshop or another image-editing program—set it to RGB mode if you're not already in it, and pick pure green with the color picker (Red 0, Green 255, Blue 0 in a standard 8-bit per channel image). Most vegetation is considerably adulterated and subdued toward varieties of gray-green, although leaves often show a purer green when backlit than they do by reflected light, something we examine in greater detail later on.

TURQUOISE

PINK TURQUOISE

DARK TURQUOISE

MEDIUM TURQUOISE

TURQUOISE

CYAN

LIGHT CYAN

CADET BLUE

MEDIUM AQUAMARINE

AQUAMARINE

JADE

If malachite is the crude green of the mineral world, jade is green at its most refined. Imperial jade is the green gem-quality variety of this favorite Asian stone.

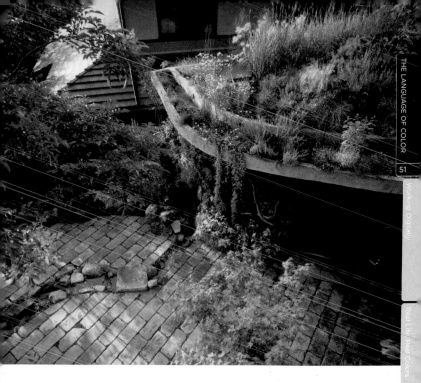

Paradoxically, perhaps, given all these positive associations, an overall greenish cast to an image is usually considered unattractive. The psychological reasons for this are complex, but involve an overall innate preference for the warm, golden glow of sunrises, sunsets, and the hearth. There is also, possibly, a minor negative in the association of green with the putrid. Most common varieties of mold are green or blue-green in appearance, such as the cladosporium, which grows on products as diverse as tomatoes, face creams, and fuel tanks.

ROOF GARDEN

The theme of this contemporary roof-terrace garden near Osaka is "green." Designed by Masatoshi Takenebe, it contains more than 300 species of plants chosen for their particular shades of green, including aquatics along the narrow stream and a rich variety of grasses and sedges on the conservatory roof. The garden also features a stream with small cascades and a specially constructed conservatory that allows for plantings on the roof and walls. The terrace is paved with oversized bricks from an old steel foundry.

Violet

The mixture of blue and red stands out among colors as being the most elusive of all, both in our ability to identify it and to capture and reproduce it photographically.

Many people have great difficulty distinguishing pure violet, often selecting a purple instead. It is worth making your own attempts and then comparing these with the color patches printed here. The difficulty in recognizing violet is compounded in photography by the problems in recording and displaying it. The gamut in color monitors and printing inks is particularly unsuccessful with this color. You can be reasonably certain of testing this for yourself if you photograph a number of different violet colored flowers. Pure violet is the darkest color. When light, it becomes lavender, and when very dark it can be confused with dark blue and blue-black. If reddish, it tends toward purple and magenta; if less red, it simply merges into blue. The difficulty of discrimination, therefore, is in the zone between violet and red.

Violet has rich and sumptuous associations, but can also create an impression of mystery and immensity. A violet landscape can contain suggestions of foreboding and otherworldliness. By extension, purple has religious, regal, and superstitious connotations. Violet symbolizes piety in Christianity, and quasi-religious beliefs, including magic and astrology. It is sometimes used to represent apocalyptic events.

Violet is a relatively difficult color to find for a photograph. In nature, some flowers are violet, but are often difficult to record accurately on film. The wavelength of ultraviolet used as "black light" is recorded by a sensor as a pure violet. Under certain conditions, the light before dawn and after sunset can appear as a reddish version of violet.

VIOLETS

| MAGENTA |
| VIOLET |
| PLUM |
| ORCHID |
| MEDIUM ORCHID |
| DARK ORCHID |
| DARK VIOLET |
| BLUE VIOLET |
| PURPLE |
| MEDIUM PURPLE |
| THISTLE |

TET FIREWORKS

Right. Vietnamese fireworks in a market stall for sale in the days leading up to the annual Tet festival.

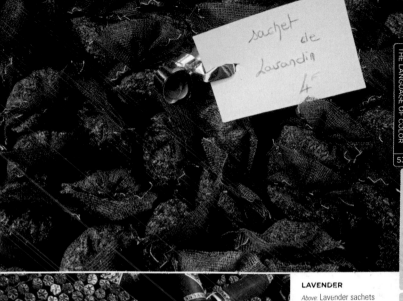

LAVENDER

Above: Lavender sachets in the market at Moustiers-Sainte-Marie, Alpes-de-Haute-Provence, France. Lavender is a color definition in its own right, yet still falls within the broad range of violet as a secondary hue.

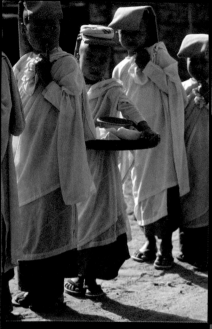

BURMESE NUNS

Above: The garments of Burmese nuns at a convent in Sagaing, near Mandalay are pink and red, as shown in the image above.

VIOLET NOTES

Right: The same garments, however, in the blue-tinged shadows of a clear day, take on violet notes.

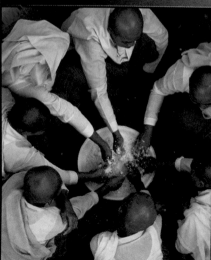

Working Digitally

Real Life, Real Color

Choosing & Using

BALINESE DAWN

Above: Bali's Gunung Agung volcano seen at dawn. Gunung Agung is Bali's "navel of the world" and "mother mountain," the axis of the Balinese cosmos. Dawn and dusk produce a huge range of colors depending on the state of the atmosphere and weather, often with unpredictable results.

Orange

Combining the strong characteristics of its two neighbors, red and yellow, orange is a rich, radiant color inextricably associated with the glow of incandescent light.

Orange is the mixture of yellow and red, and absorbs some of the qualities of both. It is brilliant and powerful when pure and, since yellow radiates light and red radiates energy, it is by association very much a color of radiation. When lighter, as pale beige, and darker, as brown, it has a neutral warmth. Orange

56

ORANGES

ORANGE

COPPER

COOL COPPER

CORAL

GOLD

MANDARIN

OLD GOLD

SIKH GUARDIANS

Right: Ceremonially attired guardians at the Golden Temple, Amritsar, in India, the focus of the Sikh faith. Orange is the third color of the Sikhs, after white and blue, and represents wisdom.

ORANGE PEARL

Opposite: An extremely rare orange pearl from the *Melo melo gastropod*, which has an orange shell. Part of a set from Vietnam, and believed to have belonged to the last emperor of Vietnam, Bao Dai, who ascended to the throne in 1932. The pearl is about the size of a golfball, and was named the Sunrise Pearl by the owner who acquired it in the late 1990s.

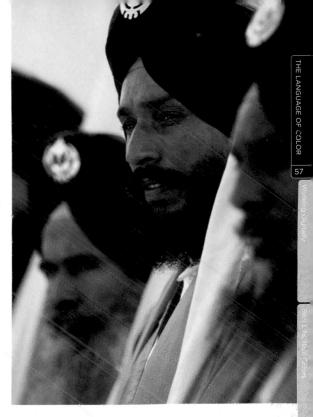

is the color of fire and of warm late afternoon sunlight. It has associations of festivity and celebration, but also of heat and dryness. Symbolically, it is interchangeable with yellow for the sun, and with red for heat.

In the world outside, pure orange can be found in flowers, and in a slightly adulterated form in the light cast by tungsten bulbs, candle flames, and other sources of low (less than 2,000K) color temperature. In film photography an 85B standard filter (a dull orange) was used with type B film (film adapted for tungsten light) in daylight to compensate for the blue cast of the film, and this has a digital equivalent in colorizing tools such as Photoshop's Photo Filter (under *Image > Adjustments*).

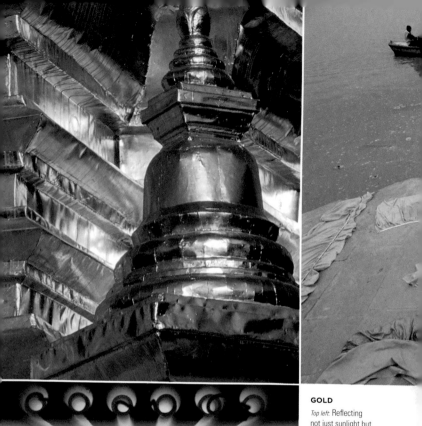

GOLD

Top left: Reflecting not just sunlight but neighboring gold, a gilded chedi in northern Thailand glows a range of orange-to-yellow.

ORANGE FROM HEAT

Left: Metal samples being heated in a laboratory furnace. A pure example of orange as color temperature.

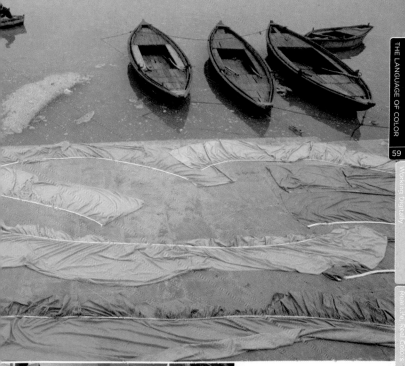

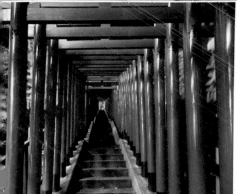

ORANGE LAUNDRY

Above: Orange sheets washed and laid out to dry on the banks of the Ganges at Varanasi, India. The men who wash the sheets are known as "dobi-wallahs."

RELIGIOUS COLOR

Left: In Japanese Shinto, this particular shade of orange, moving toward red, is a sacred color, here painted on the torii gates lining a temple approach.

Black

Black is the absence of light and tone, and in photography is produced simply by no exposure. While in its pure form it contains no detail, it is essential for establishing the density and richness of an image.

Black, being the extreme of density and solidity and the base density of an image, needs the contrast of another shade or color in order to make any kind of picture. As a result, it is used in images mainly as a background, as a shape (such as in a silhouette), or as a punctuation. Black can never be too dense. Indeed, the

limitations of a printed image on paper are often such that black appears weak, a very dark gray, and this subtly influences our appreciation of a photograph in a negative way. This slight weakness is particularly unsatisfying in a black, which ought to represent a solid anchor for all the other colors and shades, wherever it occurs in a picture; hence the importance in making sure that a small area of pure black appears somewhere in the majority of images. Although, obviously, there are many photographs which cover a softer scale of tones and benefit from a gentle

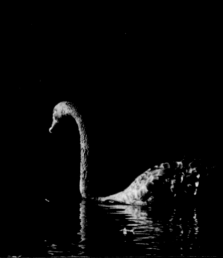

Reel Life, Real Colors

Choosing & Using

BLACK SWAN

Opposite: A variation on "black cat in a coal shed," this image of a black swan against deep shadows relies totally on its white and pale gray highlights to give form and recognition.

SILHOUETTE

Above & above right: Lit background and shadowed foreground is the recipe for silhouette, as in this image of a monk meditating in front of Rangoon's Shwedagon Pagoda. A true black reinforces the silhouette effect, and from the original shot with its fuller range (left), the black point dropper in Photoshop was used to intensify the effect in the right-hand image.

appearance—a delicate modulation in a foggy landscape, for example—most images tend to look satisfying to most people when they cover a range that has a pure, strong black somewhere in the scene. This is a natural perceptual response, and as such is the basis for the part of optimizing an image that involves setting the black point (see pages 94–5). Overexposure, low contrast, and careless optimizing of a digital image will create this weakness in the base black.

Having said that, it is also very important for the success of a well-modulated photograph to distinguish between details in the shadow areas, and this means being able to discriminate between very small differences in the lower levels, particularly between 0 and about 20 in an 8-bit image (on a scale from 0 to 255). Extreme subtleties of tone

BLACK SERIES

Right. In his black series of paintings, the Chinese artist Shao Fan utilizes almost exclusively a dark gray to black palette. He writes, "The low key and very weak contrast create an atmosphere of the supernatural. It renews our attention to the insignificant, and to things in the process of disappearing, a simultaneous feeling of distance and attraction."

in images that have blacks against blacks are interesting and challenging to explore (in painting Manet was able to achieve what Matisse called "frank and luminous black" in works such as *The Balcony* and *Breakfast in the Studio*). The master Japanese printmaker Hokusai discriminated between types of black: "There is a black which is old and a black which is fresh. Lustrous black and matt black, black in sunlight and black in shadow." He advocated a touch of blue to make black "old." The distinctions between lustrous and matt are, of course, familiar to any photographer choosing paper for prints. As a pure background, however, it can be either dense, like a solid wall, or empty, as in featureless space. If you want to guarantee that a studio background reproduces as pure black, you may need to use such a material, and then further deepen it in editing.

Where black fades to gray, the gray is very sensitive to its neutrality or otherwise. Any slight hint of a color cast is immediately recognized, and then inferred to be a part of the blackest areas. If you do not set a neutral black point in an image, it is common to have dark shadow areas that actually contain a color cast, though this may be difficult to see on a monitor screen. Boosting the monitor brightness temporarily will usually reveal this, as will running the cursor over these areas and checking the RGB values.

The neutrality of black outweighs most of its associations and symbolism, but where it appears extensively in an image it can be heavy and oppressive. Nevertheless, it can also carry hints of richness and elegance. In the 16th and 17th centuries, most notably in 17th-century Holland, it was the color of high fashion among the aristocracy.

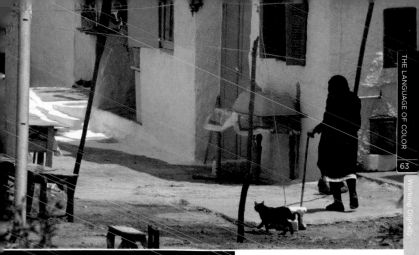

GREEK WIDOW

Above: Accompanied by her cat, an old widow makes her way along a lane in the village of Anafiotika, in the heart of Athens on the lower slopes of the Acropolis. Following tradition, she has worn black—which shows in stark outline against the whitewashed building—ever since her husband died.

BACKGROUND

Left: One of black's essential uses is to function as an empty background that, by contrast, throws an object forward toward the viewer, here the lightly colored shell of a precious wentletrap. It is easy to remove all traces of tone from the cotton velvet background through less exposure.

White

Although theoretically white is the absence of color and of tone, in practice it is the most delicate of colors and plays a very important role in almost every image.

White is the absence of any tone whatsoever. Nevertheless, just as a black object must contain tonal highlights and modeling in order to be recognizable, so a white image needs at least the modulation of pale grays or off-whites in order to be a part of an image. These slight modulations are very susceptible to color cast, however—even more than with black—and achieving complete neutrality is not easy. (This is a problem chiefly associated with gray, and we examine it in the following pages.) One famous still-life painting, *The White Duck* (1753) by Jean-Baptiste Oudry, is a spectacular exercise in the subtlety of chromatic whites. The artist wrote: "you will know by comparison that the colors of one of these white objects will never be those of the others."

Photographically, white needs care in exposure, and more so now with digital cameras than with film. Slight underexposure makes it appear muddy; slight overexposure destroys the hint of detail and usually gives an unsatisfactory sensation of being washed out. Film has a non-linear response to exposure, which means practically that, even when you overexpose it significantly, it tends to retain some traces of detail. The sensor in a digital camera, however, has a more linear response—the photosites that make up a CCD or CMOS sensor chip continue to fill up at the same rate, in proportion to

WHITES

WHITE

SNOW

GHOST WHITE

WHITE SMOKE

GAINSBORO

FLORAL WHITE

OLD LACE

LINEN

ANTIQUE WHITE

DOVES

As with blacks, exposure is critical with white subjects, and if there is sufficient time, bracketing is recommended. Typically, without adjustment an image like this would need one stop or more of extra exposure beyond that set automatically.

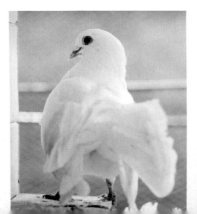

calling in the late afternoon. The small amounts of black plumage help give definition in another essentially white-on-white image.

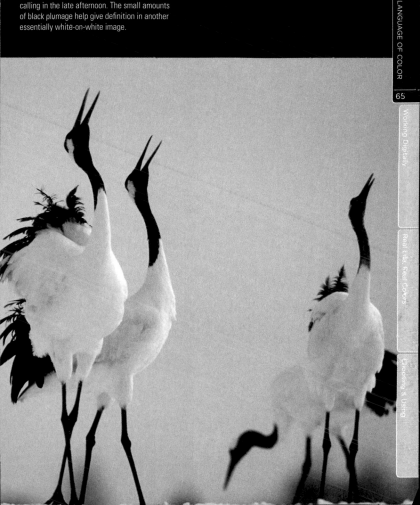

Neutral colors

Although they lack hue and fit nowhere on the color circle, the three neutral shades of black, white, and gray are essential components of color photography. Not only do they exist as counterpoints and setting for the colors just described, but they are mixed with these pure hues in varying degrees to make adulterated browns, slates, and other subdued colors. We should treat them as a special, but essential, part of photography's color palette.

the exposure, right to the top. Once full, they cannot absorb any more information, so cannot register any further subtlety in shade. The effect is that it is easier to lose all detail completely with a digital camera, and the highlights are blown out, or "clipped" as the condition is usually known. Although its neutrality robs white of strong expressive association, it generally symbolizes purity. It also has associations with distance and even infinity (as it was used by the Russian painter Kasimir Malevich in his *White On White* series between 1917 and 1918).

WHITE ON WHITE

Right. A smock hanging on the wall in Pleasant Hill Shaker village, Kentucky makes a study in white, but it is the shadows that define it and set the reference tone for the exposure.

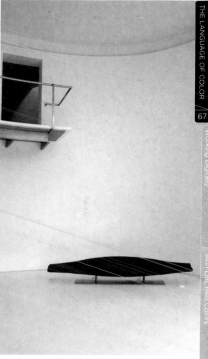

STALKS IN SNOW

Above: Snow, of course, is white, but that also means that it is highly reflective, and to appear pure it has to be seen to be seen under neutral cloudy light. Even on an overcast day, a slight bluish tinge appears.

BEACH VILLA

Above: White is the choice of color for many minimalist interior designers, punctuated with splashes of bold color. A neutral color, white reinforces the physical nature of clutter-free open spaces.

Gray

In its purest form, gray is the essence of neutrality, deadening the sensation of color in proportion to its area in the picture. It also, valuably, helps to reveal any color cast in a photograph.

Without any qualifying description, gray is assumed to be mid-gray, and this has a special place in photography. Mid-gray is exactly halfway between black and white, and on the 8-bit scale of tones used throughout digital imaging (2^8 equals 256, from pure black to pure white), it is 128 in all three channels. When printed, mid-gray reflects 18% of the light falling on it, and for this reason an 18% gray card, as it is known, is sometimes used for exposure calculations; it is the standard for an average subject, and we deal with this technique on page 87. A through-the-lens reading of 18% gray gives exactly the same exposure value as a handheld incident meter reading. Underexposing white or overexposing black produces any shade of gray, and if you use the camera's automatic exposure on either of these, the result will be a mid-gray. The digital white-balancing tools both in the camera (preset white balance, for example) and in image-editing software (such as a gray-point dropper) are designed to convert any selected color to a neutral gray, at the same time shifting the rest of the colors. Neutral density filters are also pure gray.

Nevertheless, the number of grays is almost limitless, ranging not only between black and white, but also varying in hue depending on slight color casts. If a color is heavily unsaturated, it becomes a type of gray rather than a grayish hue, and this

68

GRAYS

DARK SLATE GRAY

DIM GRAY

SLATE GRAY

LIGHT SLATE GRAY

GRAY

LIGHT GRAY

is called a chromatic gray. As the examples here show, even slight hints of color register on the eye—its very neutrality makes it a sensitive base for the slightest variation of hue.

Pure gray has leaden, mechanical associations, with connotations of being uninteresting (the word is used this way to describe people). Bluish gray expresses coolness; reddish and orange-gray warmth. Gray is the color of stone, and so also borrows associations of solidity and weight. As a group, grays are very common, not only in nature (rocks, dark clouds, water on an overcast day), but in man-made environments (concrete, plaster, streets, buildings, smoky atmospheres). Pure neutral gray is difficult to record, however, because of the eye's sensitivity to color bias. For a completely accurate 18% gray buy a gray card from a photographic manufacturer.

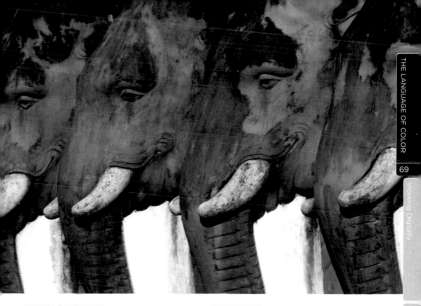

SACRED ELEPHANTS

Above: At the sacred Buddhist site of Anuradhapura in Sri Lanka, a frieze of concrete elephants guards the sanctuary. Concrete and cement are standard recognition surfaces for neutral colors (see pages 90–91 on Memory Colors).

SILHOUETTE

Below: In the tradition of the austere Zen "dry-stone garden" (karesansui) without plants, Japanese architect Kengo Kuma designed this "stroll garden" of andesite stone and water in Tochigi prefecture, north of Tokyo. Called Stone Plaza, the commission was for a company that quarries and sells the local pale gray stone. The water garden and buildings are open to the main street

COLD BEACH

Above left. The Massachusetts coast in the depths of winter under a leaden sky that has completely drained any color.

CARRARA

Left. These are the Tuscan quarries from which the famous, and white, Carrara marble is hewn. The shadows must appear gray after editing.

MOTHBALL FLEET

Above. Rows of naval vessels off the Californian coast. Gray is the standard paint for ships of all the world's navies.

Neutral blacks, whites, and grays

Gray by definition is neutral, meaning no hue and no degree of saturation. However, in the range of tones in a photograph, it is possible to have the mid-gray neutral while the blacks and whites are tinged with color. The core techniques of balancing color digitally, as we'll come to on page 88, are setting all three to neutral—at least when they can be identified in the image.

Case Study: **Chromatic Grays**

Because of its neutrality, its lack of "color," we are very sensitive to the accuracy of gray—or so we think. Yet ask any two people to point to a perfectly neutral gray and you're unlikely to find agreement. The measurable differences may not be far apart, but the opinions probably will be. Fortunately, the means for measuring exact neutrality are instantly at hand digitally, and RGB is for once the most easily read color mode. In a truly neutral gray the three values are the same. We can easily distinguish slight differences in hue, though only when we see them side by side. This spread is more like a project with two objectives: to find and assign a full range of these so-called chromatic grays, covering at least the six primary and secondary hues, and to find the limits of gray. At what point with the addition of hue and saturation does the result become a distinct color rather than a colored version of gray? Naturally, there are no fixed answers.

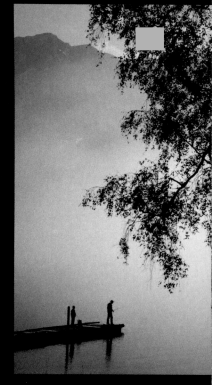

SUBTLE DESATURATION

Below: This is the full spectrum of hues, exactly as reproduced on page 27, with a vertical dark-to-light gradient, and 96% desaturation applied.

NEGATIVE SPACE

Above: Boys fishing from a pier on the Altausseer See, Salzkammergut, Austria. The low-lying morning gives us a beautiful study in grays.

ROOTS AND STONE

Left: Warmer grays are found in a strange combination of the roots of a ficus that have grown around and lifted the head of a Buddha sculpture in the city of Ayutthaya, Thailand.

BLUE MUD

Left: It's important when shooting near neutrals to see and remember the subtleties of hue. The mud in which these Namibian elephants were bathing in Etosha was actually a pale blue. If I had failed to notice, I may later have "corrected" it to true gray.

WORKING DIGITALLY

With digital photography there is both the necessity
and opportunity to control and adjust color in
ways that are completely new to photography. This
might seem an inconvenient distraction from the
photography itself, but it is unavoidable, becomes
easier with practice, and in the end pays dividends.

The necessity is because, unlike with film, there is never a single point in the process at which the colors of an image are fixed. Traditionally the moment of exposure established how the colors would appear. You could change the way it was printed, either in the darkroom or in repro, but the original film would always remain the reference. Digitally, the image is captured with much more flexibility, and the color of each individual pixel is open to change at any point afterward.

The opportunity lies in choosing exactly how any and every color should look, regardless of what it was in the scene or as captured. This opens up possibilities for creative expression that until now have been foreign to photography.

The techniques for handling color digitally all require a familiarity with software, in which I include the firmware installed in the camera. If you simply want to shoot without having to consider image qualities such as color, you need no more than the basic version of the camera manufacturer's downloading and browsing software. If you want full color control, however, the list of software to consider expands greatly.

Then there is specialist software aimed at very specific aspects of digital color. One important area is camera profiling, used in conjunction with standard color targets. Monitor calibration and printer profiling, also part of the digital color workflow, call for specific hardware and software. At first this might seem very daunting, but the principles are relatively straightforward and the software does the hard work. Beyond this, new software is being developed all the time to deal with newly identified issues, such as memory colors, or to take advantage of improving camera or computer power, such as high density range facilities. Keeping up to date with these new software programs and evaluating them is now, for better or worse, another part of digital photography.

SUNSHINE

Hiroyuki Numata continues a 1200-year-old tradition: the prestigious ritual of Ukai, in which cormorants are used to catch sweetfish. Images like that that are taken in bright sunlight can sometimes appear flat, and need to have the color fixed in post-production.

Color Management

In digital photography, the number of different devices used in the workflow, from camera to monitor to printer, makes it essential to control the color so that it stays consistent.

Color management is the process by which you ensure that the colors you see in the scene in front of the camera are kept as they should be throughout the several stages of capture, editing, and delivery. It is, and is likely to remain, a hot issue in digital photography, because before you can use color creatively with any degree of subtlety, you need to be confident that the combination of equipment and software that you are using will deliver exact colors when you need them.

And yet, while digital imaging now provides all the means for controlling color, color management was never such an issue in the days of film, which often suffered more from color shifts and inaccuracies. The key to this seeming inconsistency is that with film there was a physical object to which everyone could refer. Even if the colors in that piece of film were wrong in some way, and

allowing for some differences in the quality of the light box on which it was viewed, it remained tangible. Now, with digital photographs, there is no single reference image, only versions of it that depend on the viewing platform—and computer monitors and the systems on which they operate are hugely variable.

The software used for managing color is called a Color Management System (CMS), and for any serious photography is absolutely necessary. Fortunately, color management is now standard with most good cameras, computers, and imaging software. If you have at least an accurate generic camera profile (normally automatically readable), a calibrated monitor, the right entries in Photoshop's Color Settings, and a calibrated printer profile, your color management is likely to be in good shape.

Color gamut is the range of colors that a device (camera, monitor, or printer, for example) can display. A CMS maps the colors from a device with one particular gamut to another. Typically, the CMS uses a Reference Color Space or Profile

SHOOTING MENU
Image area — —
JPEG compression
NEF (RAW) recording — —
White balance AUTO₂
Set Picture Control SD
Manage Picture Control — —
Color space sRGB
Active D–Lighting OFF

Basic workflow

Color management is essential in cases where color must stay consistent from capture to output. It requires the conversion of all color descriptions to be converted into an independent color space. This takes place within the computer. While cameras and scanners apply their own idiosyncrasies, monitors and printers can also display colors wrongly. The CMS allows for all this, to make the display as close as possible to the original.

Connection Space that is independent of any device, and a Color Engine or Color Management Module (CMM) (see Color Management Modules box). So, for example, a CMS converts monitor RGB colors to the smaller gamut of printer CMYK colors by using an intermediate color space that is larger and device-independent, such as L*a*b*. Thus, it converts from RGB to L*a*b* and then to CMYK, changing some of the colors according to the render intent. This determines the priorities in the process, in which inevitably some need to be altered (see the Render intent box).

Color Management Modules

At the heart of the Color Management System is the Color Management Module (CMM) or Color Engine. A CMM translates or maps one color space or gamut to another via an independent Reference Color Space or Profile Connection Space. As available colors vary between gamuts, some colors will be "out of gamut" when the mapping occurs. A CMM will use color profiles and render intent to optimize the colors between the two devices so that they match as closely as possible.

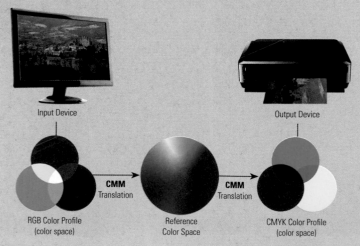

Input Device

Output Device

CMM Translation

CMM Translation

RGB Color Profile (color space)

Reference Color Space

CMYK Color Profile (color space)

Render intent

Some colors will be out of gamut when you change from one color space to another, and so the color management system needs your guidance in how to affect the compromise. This is known as render intent, and Photoshop offers four choices.

- With a **perceptual** intent, the color space is simply shrunk.
- With a **saturation** intent the vividness of colors is preserved (more useful for graphics than for photographs).
- **Absolute colorimetric** makes no adjustment to the brightness.
- **Relative colorimetric** changes only those colors that are out of gamut between the two spaces, and is the normal intent for photography.

Color Space

A color space is a model, often represented as a three-dimensional solid, for describing color values, and it has a "gamut," or range of colors that it is capable of recording or displaying.

The standard color space for digital photography is RGB, defined naturally enough by the three components red, green, and blue. Camera sensors use an RGB filter to distinguish colors and computer monitors display colors by mixing RGB. In practice, there are a number of RGB spaces, including sRGB, Adobe RGB, and ProPhoto RGB, some larger than others and covering slightly different areas of hue. You might wonder, what could be better than the largest color space possible, and what could be the advantage of a small color space? The answer lies in the final form in which the photograph will be displayed—as an inkjet print, for example, or as a CMYK print in a book, or on-screen. The wide gamut of a large color space can indeed record many subtleties of color, but this is no use at all if you can't display them. Color spaces are matched to different purposes, and the two most widely used are sRGB—small, but ideal if you go straight to print from the camera without image editing—and Adobe RGB, which is wider and better suited to image editing in Photoshop.

WORKING SPACE

The two most common color spaces available in digital photography are Adobe RGB (1998), the larger of the two shown here, and sRGB. The latter is convenient for printing, but fails to capture as many greens and reds.

DEVICE SPACES

The color gamuts of an 8-bit monitor (white) and digital color print paper (pink) compared (in so far as is possible when printing using CMYK). For comparison, the gamut of an average color transparency film (blue) is superimposed.

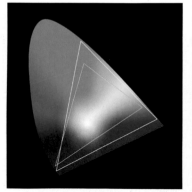

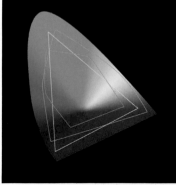

Other color spaces

Although the RGB color space is standard in photography, it is arguably not the most convenient way of editing images on the computer. There is another color space, HSB (or HSV), which more closely emulates the way in which our eyes perceive color. The HSB model describes colors using the three parameters discussed earlier: hue, saturation, and brightness (the V in HSV stands for Value). Most image-editing software draws on this color model in the form of their color adjustment controls. Photoshop's **Hue/Saturation** dialog for example features Hue, Saturation, and Lightness sliders, while Lightroom's **HSL/Color/B&W** pane allows you to adjust the Hue, Saturation, and Luminance (as opposed to Lightness) of eight colors. Drawing on the HSB model makes color adjustment a more intuitive process.

Another often discussed color space is L*a*b* or Lab. Lab also has advantages over RGB, although not quite so obvious. Remember that Lab was developed as a very large color space rather than as a user tool. In fact, Photoshop uses Lab as an internal color space when making some changes. By separating Lightness as an individual channel, Lab is at its most valuable when you want to make brightness changes with no effect whatsoever on the balance of colors.

Another wide gamut color space is ProPhoto RGB. This space is now available and commonly used in a number of editing programs including Photoshop and Lightroom as it offers the greatest color flexibility when editing 16-bit files. However, it's important to remember to save the final 8-bit file in a smaller color space for output as few devices can display or print all the colors available to ProPhoto RGB.

Large color spaces do play an important role, but as intermediate spaces for conversion. L*a*b*, developed in 1976 by the Commission Internationale d'Eclairage (CIE, and so this space is also referred to as CIELab), was designed to match human vision as closely as possible in the way we perceive and appreciate color. It has three parameters, or axes: one for brightness and the other two for opposing color scales. L* stands for luminance (that is, brightness), a* for a red-green scale and b* for a blue-yellow scale. The logic behind this is that each of the three axes oppose complementaries—dark against light, red against green, and blue against yellow. In human visual perception, red cannot contain green, nor blue contain yellow. Being a large color space, it is also useful for converting colors from one model to another, as nothing is lost. Indeed, Photoshop uses L*a*b* internally for converting between color modes, and it is available for image editing. Nevertheless, it is what is called a device-independent color space.

The other color space that figures largely in professional photography is CMYK, representing the inks used in printing books, magazines, and the like. The initials stand for the three complementaries of RGB—cyan, magenta, and yellow—and K, meaning key, for black, which is a necessary ink in printing to achieve full density on paper. The CMYK color space is significantly smaller than others used digitally, so while it is an essential last step for repro, it needs skill and experience to use because colors can be lost in the process of conversion. Most photographers leave CMYK conversion for the printers or client to do.

Calibrating Monitors

The monitor screen is where all the important decisions about digital color are made, and the procedure for making sure that the display accurately represents colors is calibration, an essential first step.

As supplied with the computer and without adjustment, the monitor display will give you a reasonable accuracy of color—usually. For professional or creative color adjustment, however, an unknown level of reasonable is not good enough. Moreover, calibration to an adequate degree is easy, and often provided at system level by your computer (if not,

consider another computer!). At the very least, you want to be sure that you are displaying neutral grays as truly neutral, not only for the mid-tones but also for the blacks and whites.

Before all else, make sure that the viewing conditions are good. Simply put, this means that the ambient light level in the room should be at least half of the brightness of the screen and that the surroundings of wall, desk, and so on are neutral, not colored. Needless to say, the screen desktop should be a simple neutral gray, not a photograph of the family or the dog.

Monitor calibration is the starting point for color management, and there are two basic methods: by eye and with a measuring device. The eyeball method is not bad at all, and is available at system

LIGHTING
An ideal lighting environment, with soft daylight from behind the monitor (to cut down on reflections).

SPYDER

A colorimeter is used to measure your monitor's performance and create a profile for it. Simply place it on your screen and the software supplied will cycle through some colors and create a profile.

COLORMUNKI

X-Rite, the company behind the popular ColorMunki and i1 calibrating systems, has created a display calibration kit for amateur photographers called the ColorMunki Smile. The wizard-driven software shows you how to set up the colorimeter, and then automatically calibrates the monitor with little or no user input required.

level on modern Windows and Mac operating systems, via a setup assistant. The sequence prompts you to adjust by eye the brightness and neutrality of the black, white, and mid-points, also the gamma (see box for definition) and the color temperature. You then save the results as a monitor profile.

More accurate is hardware calibration, using either a colorimeter or a spectrophotometer placed on the screen to measure the actual display. These devices come with software that runs a program of color variations, at the end of which a monitor profile is automatically created.

Gamma

The angle of slope of the response of a monitor to a signal is known as gamma—technically a plot of the intensity of the output signal relative to the input. The standard gamma for photography is 2.2.

In-camera Color

The starting point for color correction is the camera itself, which contains options in its menu for white balance and, in some models, hue adjustment.

The camera menu offers a number of controls for getting close to an accurate color, and the one that receives most attention is the white balance. The principle of this is that by setting the whitest part of a scene to neutral, you will in effect have adjusted the sensor to the light source. As we saw earlier, the color of lighting varies greatly. This is no problem for the sensor, provided that it is given some help. The menu contains several precalculated settings for sunlight, cloud, shade under an open sky, and fluorescent lamps. These will usually get close to an accurate balance. There is also an auto white balance setting which will calculate the color balance from its analysis of bright tones in the scene. High-end cameras have a further option, called preset, in which you aim the camera at a white or gray card in the lighting that you will be using for a session; the camera then sets this as neutral.

Higher-end digital cameras offer a choice of image formats that includes, in addition to the normal TIFF and JPEG, the Raw file. Actually, each manufacturer's Raw format is unique and tailored to the design of sensor and the camera's imaging engine. What they all have in common is that the data collected by the sensor is kept separate from the settings (which include exposure, contrast, and white balance, among others), so that it can be accessed later. Also the original high bit depth is maintained, and in a high-end camera this is likely to be 12 bits per channel (4096 rather than 256 shades per channel). Image-editing software like Photoshop and Lightroom, capable of editing up to 16 bits per pixel, can take advantage of all this data, uses this difference to give the typical Raw file an exposure latitude of four stops. Practically speaking, you can recover up to two stops of exposure either way; the upper limit is set by the image's highlights. Once a pixel has reached its maximum brightness value nothing can be recovered from it.

The advantage of Raw

For fine color control, nothing beats the Raw format available as an option in better digital cameras. It allows you to revisit the original settings with no loss of quality. You can, in effect, defer the delicate decisions about color until later, when you have more time to consider the editing, and you can be confident that as long as you have captured the maximum amount of information in the camera, and have avoided clipping the highlights, you will be able to adjust any and all of the colors as much as you like. This only works, of course, if you are prepared to spend the extra time involved converting and editing the Raw images.

Bit depth and color

Bit depth is the number of discrete levels of tone that can be recorded and stored, and in many ways is the key to full color control in digital photography. It is sometimes referred to by channel, sometimes by all three RGB channels together. The standard bit depth, and the only one for display on a monitor screen, is 8 bits per channel, or 24 bits overall. Image files, however, can contain more data. 16 bits per channel is supported by Photoshop and Lightroom, which, even if not seen on screen, provides much more latitude in editing (up to 281 trillion colors instead of the 16.7 million in an 8-bit per channel image).

Recovering exposure

Color is strongly affected by exposure, which is in any case a primary technical concern of photography. Raw format, properly exposed, is the silver bullet for exposure difficulties. Raw converter software such as Lightroom or Aperture allows you to revisit the occasion of shooting and choose a different exposure setting of up to two stops in either direction. However, this magical 4-stop exposure latitude has an important limit—you must expose for the highlights. Once a pixel has been exposed up to 255, or even a couple of levels below, the color values have been irrecoverably lost.

Camera Profiles

In the same way that a monitor can be profiled by calibration, the unique characteristics of your camera's sensor can also be measured and used to color-correct images.

While the very simplest way of using them is as a basic eyeball check when you open up the digital files in a browser or image-editing program, the most accurate way of using them is to create an ICC profile. These profiles (ICC stands for International Color Consortium) are the basis of color management systems, and are small files that can be accessed at system level by the computer. A program such as X-Rite's ColorChecker Passport can read the photograph of the chart after you shoot it (see below), compare it with the known values, and construct a small file known as a camera profile that will instruct editing software to make the necessary adjustment for any image that you choose. Simple and highly effective, but a camera profile will be accurate only for that exact lighting, which makes it more useful for controlled studio or indoor conditions than general shooting.

GretagMacbeth ColorChecker

A 24-patch mosaic of very accurately printed colors, including neutrals and "real-life" colors such as flesh tones, sky blues, and vegetation. This is the standard color target for photography, though relatively costly because of the special printing. Even more expensive is the GretagMacbeth ColorChecker DC, which has many more color patches. Because the colors are printed matt, the range from "white" to "black" is quite short, and the "black" is really a dark gray. One precaution when making a profile is to make sure that the white and black are close to the recommended values.

Shooting the target

1 Place it square-on to the camera.

2 Make sure the lighting across the chart is even.

3 Use low sensitivity and meter as average.

4 Set the exposure so that there is no clipping of highlights or shadows.

5 For making a camera profile, follow the software instructions.

Gray Card

Not for making a camera profile, but still very useful for guaranteeing the basic neutrality in an image, is an 18% reflectance gray card. In a digital image it should measure 50% brightness and R128, G128, B128. The reason for 18% as a mid tone is the non-linear response of the eye to brightness.

PROFILING SOFTWARE

There are several examples of camera profiling software available, including Adobe DNG Profile Editor (available free to download) and X-Rite ColorChecker Passport software which comes bundled with the ColorChecker Passport targets.

Creating the profile using Lightroom and X-Rite ColorChecker Passport software

1 Import the image of the target into Lightroom as a DNG file.

2 Export the target file from Lightroom.

3 Open the ColorChecker Passport software and drag the target DNG file into the drag and drop window.

4 The software will automatically identify the target, assess the colors and create a camera profile to ensure accurate colors under the specific lighting conditions in which the target was shot.

5 Save the profile in the Lightroom CameraProfiles folder. Restart Lightroom and the newly created custom profile will be available under the Camera Calibration pane.

A Question of Accuracy

Ultimately, colors in photography are judged by eye, not by machine, which means that accuracy involves both measurement and perception.

The tools for color control that we've been looking at operate on the premise that there is such a thing as perfect color correction—that for every photograph there exists one accurate version. Inevitably this leaves aside individual interpretation, but how reasonable an assumption is that to make? In some cases it is fair, but these are remarkably few and tend to be limited to specialist reproduction of pack (product) shots and artifacts such as textiles, paintings, natural history and other scientific specimens, and the like. For most photography the criteria are different.

We assume we know when the colors in an image are correct, which is to say as they should be. In reality, most people hardly think about it at all, and the question arises only when a color appears to be seriously wrong. If, for instance, sunlight falling on a surface appeared to have a tinge of green, we would "know" immediately that that shouldn't be so. And how do we know that? By experience, which, if you think about it, is not a very good basis for judging how any of the several million colors that we can recognize should be, and certainly not easily comparable with the scientific approach.

Nevertheless, as eye judgment by someone is the final arbiter, it has to be factored in to the equation. Unless you go to the trouble of making a camera profile, which for reasons already explained (see page 86) is not normally practical, then all the other tools for color control require some opinion or prior knowledge of what a color should be. This applies equally to choosing a neutral in a photograph, a memory color (see page 90) such as skin tones or sky, or even the quality of light, from cloudy, through shaded, to incandescent. As we saw, there is a wide latitude built into all of these, and this latitude allows for choice. Camera profiling is as close as you can get to verifiable accuracy, yet even it has limitations. Even though a camera profile for one specific lighting situation will guarantee that the colors measure correctly, this is still not a solution that accounts for all factors, since it ignores perceptual accuracy. The obvious case, though by no means the only one, is when the sun is low and the color temperature is lower than midday "white." If you diligently use a color target in the manner described on page 86, or even if you simply photograph a gray card and use that to set the neutral gray balance of the images, the results will be measurably correct but will look wrong. Quite apart from any subjective feelings that you may have about early morning and late afternoon light—the attractiveness or otherwise of a scene bathed in golden light, for example—we expect this kind of situation to look warm.

AS SHOT

Above: The scene, a new hotel in India, as shot with a Sunlight white balance. At the same time a ColorChecker was shot.

ACCURATE

Above: In this example, the ColorChecker is used as a guarantee of accuracy, after the shot has been taken. The profile makes no allowance for the "warmth" of the afternoon sun.

BY EYE

Above: In a case like this, if you want to add warmth, you will have to lower the color temperature by eye after assigning the profile.

Memory Colors

One of the most valuable methods of evaluating overall color accuracy, though it needs to be used with caution, is to focus on the colors of things with which we are so familiar that we know innately how they should appear.

Certain kinds of color are more fixed in our minds than others, meaning that we have finer discrimination and stronger opinions about whether they are accurate or not. To an extent this varies from person to person, and depends on particular interests, but there are a few standard sets that most of us recognize. They are known as memory colors because they seem to be embedded in our visual memory. Naturally, they play an important role in image editing because they are an immediate key to assessing the color accuracy of a photograph. For memory colors we can most easily say whether they are "right" or "wrong," and to what degree, and we can do this intuitively. Measurement is important in optimization, as we saw, but as color is ultimately a matter of perception, never underestimate the importance of subjective judgment. If it looks right, it is right.

The two most important memory colors are those with which we have the most familiarity: neutrals and skin tones. Following this, there are green vegetation and sky tones. It also depends on the environment in which you grow up—if you live in New Mexico or North Africa, you will be more attuned to the colors of sand and rock than if you live in northwest Europe. Adjusting the memory colors in a photograph involves matching them to known samples. At its simplest, this means relying on your memory at the time of correction, but you can refine the process by referring to samples that you already accept as accurate. One way is to open a second image that is already well-adjusted and use it for reference. Another is to build a set of color patches that represent

SKIN

Below: In the same way that we are highly sensitive to all aspects of the human body (for instance, face recognition), we have an innate judgment of the color of skin, which has to fall within an expected range. Note, though, the differences here even between two pale Caucasians.

CONCRETE

Above: Urban concrete in its many forms is taken by the eye as a neutral, and makes a good reference for adjusting digital images in post-production.

Neutrals

Objects and surfaces in a photograph that should be neutral include concrete, steel, aluminum, automobile tires, asphalt, white paint, black paint, and midday clouds.

memory colors that are correct for you. There is also software, such as iCorrect Professional, that deals specifically with memory colors. The adjustment approach is basically that of source and target.

MONTREAL PARK

Above: Plant life, such as grass, is another memory color, although the range of acceptable greens is wider than for most other memory colors.

Personal Colors

The key to the success of the X-Rite/GretagMacbeth ColorChecker is that it contains "real-life" colors. But each photographer has preferences and a range of colors that have a particular relevance.

While specialist printing, in the way that the ColorChecker is produced, is out of the question, it can be useful to create color patches that are closely tailored to your own experience and preferences. If you have a feeling for color, then you are probably attracted to certain kinds of color. Equally, if you spend most of the time with a camera photographing a particular range of subjects (such as flowers, people, or buildings), or in a specific location (be it the Arizona desert, the Florida Everglades, or the English countryside), then you will automatically be working with a special selection of colors.

This makes a useful project for two reasons. One is that you will have, at the end of it, a worked-out reference for specific colors that you want to get right—and get right consistently. The other is that it helps to exercise powers of analysis,

SIMPLE LINES

Below: The Meeting House at Sabbathday Lake, Maine. This Shaker community highlights the extreme simplicity of Shaker architecture.

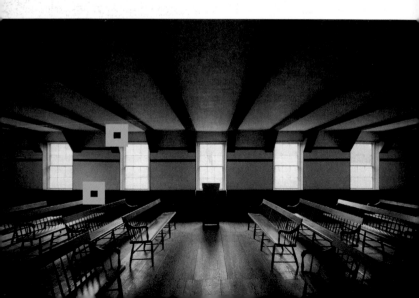

NEUTRAL TONES

Below & right: The palette of this series exploring a Shaker community in Maine is made up mostly of neutrals and muted, natural tones.

and encourages the identification of which colors you come across the most often. In Photoshop, make a grid of about 20 squares, as shown here, and then fill each of these with a color that is relevant to your particular photography. One aid to this is a review of your own photographs, using the browser, and then sampling specific colors. To do this, open any image, click on the Eyedropper tool in the toolbox, then click with it on the color you want. Go to the blank color chart and, using the Magic Wand tool, click on a blank square to select it, then fill with the chosen color. Alternatively, use the Color Picker to create a color that you want.

FILL SETTINGS

Above: After you've made your grid, set the Fill settings to Foreground Color, and choose Normal mode, and an Opacity of 100%.

Black Point, White Point

The most basic, simple, and effective technique for bringing the colors and tones of a digital image to their optimum is to find the darkest and lightest points and make them firmly black and white, respectively.

The process known as optimization is designed to make an image appear at its best by making the fullest use of the gamut of the monitor and printer. The first step is to spread the range of tones and colors captured as widely as possible over the 8-bit scale from black (0) to white (255). This is known as setting the

black point and white point, and there is a choice of techniques. In Photoshop, the starting point is Levels. There are three sliders below the histogram, one each for black point (left), white point (right) and mid-point (center). Drag the black-point slider in from the left until it reaches the first group of pixels in the histogram. These are the darkest pixels in the image,

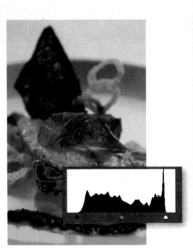

ORIGINAL

Above: When you open the Levels dialog to edit the original image, the histogram has distinct gaps at either side, suggesting an image without very dark or very light areas.

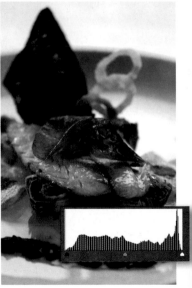

AFTER

Above: After applying the settings shown to the left, the tones have been stretched across the histogram, for a more contrasty image.

Setting target blacks

Printers fall short in their ability to reproduce true blacks and whites. Set the black and white points to somewhat less than the extremes by double clicking the black-point and white-point droppers and entering new figures. Reasonable settings are 10, 10, 10 in RGB for black and 243, 243, 243 in RGB for white. Note, however, that if your system is color managed and you're using a desktop printer Photoshop automatically adjusts the image so that highlight and shadow detail prints accurately.

Optimizing in Lightroom

Optimizing an image in Lightroom is less prescriptive compared with setting the black and white points using Levels in Photoshop. Although Lightroom doesn't feature a Levels dialog, it does have a number of controls in the Develop module that allow you to set an image's highlights, shadows, and midtones (which is essentially what you're doing when setting the black, white, and gray points in Photoshop). The suggested optimization route in Lightroom is to start with the Exposure slider in the Basic pane to set overall brightness, and work downward using the rest of the sliders to set the shadows and highlights. As you move the sliders you'll notice the relevant area of the histogram changes shape. In the vast majority of cases you want to ensure the histogram stretches all the way from left to right, but avoid having pixels bunched up against either end as this will indicate the image is clipping either in the highlights or shadows.

and doing this will make them black. Then do the equivalent with the white-point slider. Click OK. To check the result, reopen the Levels dialog and you will now see that the histogram has been stretched to fill the full scale. A useful check when doing this is to hold down the Alt/Option key as you drag the sliders. With the black-point slider the image on screen will be pure white until you reach the first pixels—it will indicate at what point you begin to clip the shadows. With the white-point slider the same key has a similar effect, except that the base color on screen is black.

An alternative method is to use the black-point and white-point droppers to the bottom right of the dialog. First, click on the black-point dropper, then find the darkest shadow in the image and click on it. Follow this by clicking on the white-point dropper, then find the brightest highlight in the image and click on that. To find the darkest shadow and brightest highlight, either use the technique just described, or else run

the cursor over the image while looking at the results in the Info palette.

Once black and white have been set in an image, the next step is to establish those tones that you think should be gray as perfectly neutral. The most direct method is to find a point in the image which you know should be neutral, or which you would like to be neutral, and then click on it with the gray-point dropper. Having first found an area that should be neutral, run the cursor over it and watch the Info palette to see if the RGB values are equal.

Color & Contrast

Contrast is not simply an issue of exposure and tonal range. It affects the intensity of colors, and the problem with high contrast scenes is holding color values.

Exposure is a matter of color. Too little will produce dark and muddy hues, while too much will bleach them out. It is common to think of color as a matter of hue and saturation, with brightness as a separate issue, but this is wrong. In photography, as in nature, color is defined by three qualities—hue, saturation, and brightness—and the last of these depends on the exposure setting. Color, therefore, is dependent on the range of contrast in the scene.

High contrast has always been a problem in photography, because the dynamic range of the materials—whether film, sensor, or paper—is just nowhere near as high as the eye's ability to distinguish tones. Digital sensors have a special problem in that their response to quantity of light is linear. The individual photo-sites fill up in proportion to the light falling on them. Crudely put, most digital camera sensors overexpose easily.

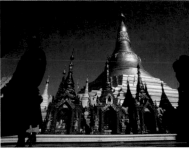

This apart, digital photography does have solutions. Provided that the pixels captured do have some recorded value— that is, a few levels above 0 and a few below 255—they can be restored and enriched if wanted. The traditional advice for slide film works well for digital: expose for the bright areas and let the shadows go. This is fine up to a point, if the shadow areas are small or will work well as silhouettes but, if not, there are two valuable techniques that can restore the color values across a wide range of shadows and highlights. One is to shoot Raw, which automatically gives you an exposure latitude of up to four stops in post-production. The other is bracketing: to shoot a sufficient number of exposures so that you capture both highlight and shadow details.

The next step is to blend them in such a way that the best shadow and highlight detail is preserved in the final image. The most primitive approach to this, though still effective, is to paste one on top of the other as a layer in Photoshop and use the Eraser tool to remove the less well-exposed areas. Another is to make either a highlight

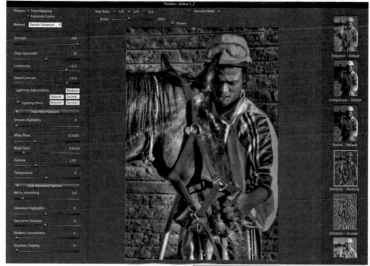

HIGH CONTRAST

Left: These two very different images both show a diverse, and contrasty, range of colors. In the upper image, the dark trees stand out against the bright yellow, while in the lower image the red and gold buildings stand out from the darker sky.

TONE MAPPING

Above & right: One popular approach to high contrast is to map the color information from a 16 bits image into a normal, viewable 8-bit per channel. The algorithms are more complex than simply squeezing the range of values, but the result is to include the best of the shadow detail and the best of the highlights. Tone mapping can produce images that range from naturalistic to surrealistic in appearance.

EXPOSED FOR HIGHLIGHTS **EXPOSED FOR SHADOWS**

mask or a shadow mask, apply this as a selection to the upper layer, and delete. A third is to adjust the curves and choose an appropriate blending mode (Screen or Multiply). By far the most effective treatment, though, is tone mapping, in which a sophisticated algorithm is applied

to map the pixel values from this high dynamic range to a regular 8-bit image. The software shown here, Photomatix, allows variations in the mapping to favor brighter or darker areas, and also valuably maintains local contrast.

The Subjective Component

So much effort is spent in ensuring color fidelity that it's easy to ignore personal taste and preference. But your work should express a visual idea as much as get things "right."

Color management has reached the point of being an obsession for many digital photographers because the technology exists and calls for attention. The different hardware (including the camera) and software need coordination, and this is what makes color management essential. But the reality is that to handle color well, as a colorist, you must have an opinion about it. Getting color under measurable control is a first and important step. Making your own color statement is the next.

One of the clearest examples of the validity of subjective opinion in color is in the choice of the level of saturation. As we've seen on page 81, HSB/HSL is perhaps the most comfortable, rational way to adjust color, yet psychologically we attach different weight to these three parameters—hue, saturation, and brightness. Hue is generally considered the essence of color. Brightness tends to be thought of, particularly by photographers, as being tied more to exposure and tone than to hue, leaving saturation as the principal modulator—at least in most people's judgement.

The point that I'm making here is that there is a more readily accepted creative latitude in saturation than in other color parameters, and we certainly see evidence for this in color repro for books, magazines, postcards, and the like,

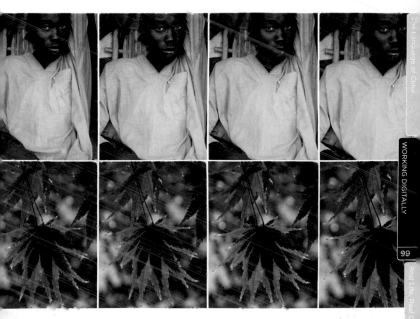

LEAF

Above & opposite: A more colourful image than the portrait, with some obvious tendency toward richness and full saturation. Increasing saturation strongly is a temptation. (Left to right: saturation +33, +22, +11, as shot, −11.)

TOBACCONIST

Top: A Dinka tobacco seller in the Sudan. This is an image about color, in particular the relationship between a particular yellow cot and very dark skin. (Left to right: saturation −11, as shot, +11, +22, +33.)

where it is frequently altered in the production process. As an experiment, here are two images offered at different saturations. To get full value from the case study, first decide, after studying the choices, which you prefer. Then cover up all the other versions and let your eye accommodate for a few minutes to this one. Even come back to it after a break.

Then uncover the other images. Has your perception and judgment changed? Finally, what is the range of saturation that you personally find acceptable? The exercise is even more valuable with one of your own images. The lesson, of course, is that there is indeed a range, not a single point of acceptability.

Printer Profiling

The third and final piece of equipment in most photographers' workflow is a printer, and this too needs an accurate profile, which can be properly done only with professional calibration.

Profiling, whether applied to cameras, monitors, scanners, printers, or even projectors, is the way to guarantee color accuracy, and is the basis of a sound color management system. In the past, printer profiling usually needed professional external input, but today, affordable spectrophotometers combined with easy-to-run software such as X-Rite's ColorMunki Photo system make printer profiling a relatively straightforward "in-house" job. Once your screen and printer are calibrated and profiled you can then have total confidence that what you see on the screen will be very close to what you get as a print.

With cameras, as we saw, profiling is useful only when the lighting conditions are precisely the same for target and shooting, as in a studio. With printers it is not only essential, but also predictable. As long as you stick to a known set of papers and inks, the profiles you use will always produce the same results. Printers make colors in a completely different way from digital cameras and monitors. They use process colors (cyan, magenta, and yellow, plus other inks such as black, gray, and light magenta) and the image is reflective rather than transmissive. The implication of this is that a spectrophotometer is needed to measure the pigments, and this is what is supplied with X-Rite's ColorMunki and i1 systems.

COLORMUNKI
X-Rite's ColorMunki Photo system is an affordable and straightforward way of calibrating monitors and creating custom printer profiles. To start, place the spectrophotometer on the screen and the software generates a number of colors on the screen which are measured in turn. Essentially the software compares the colors measured from the screen with what the colors should be and makes any necessary adjustments to the monitor automatically.

There is now a wide variety of paper and inksets for inkjet printers, and it is worth experimenting to take full advantage of these options. Having decided on which to use, the normal procedure is to print out a digital test target supplied with the profiling system and then measure this with the spectrophotometer. The software will then create a custom profile specifically for your printer. This corrects for the difference between the way your printed image looks and the way it should look. In practice, there would be one profile per paper/ink combination.

PRINTER PROFILES

Having calibrated the monitor, the next step to ensure color consistency between monitor and printer is to print the color target. Then, using the spectrophotometer again, the colors from the printout are assessed against the colors as they should be. The software then creates a custom ICC profile for the printer so that what you see on screen is what is printed.

REAL LIFE, REAL COLORS

Having looked at the basics of color in chapter one and at the digital techniques for adjusting it in chapter two, we can now turn to how color appears in the real world in front of the camera. With all the possibilities for tuning, enhancing, and even creating color that digital photography and image editing offer, we must always start with the colors of real objects in real scenes.

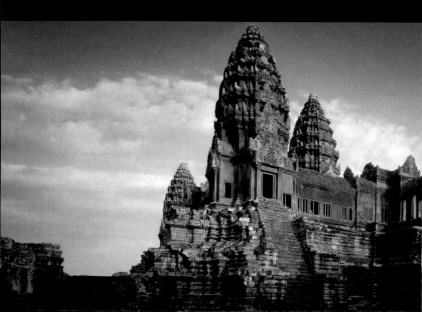

The values and associations of individual colors are complicated immensely as soon as they are seen in the context of other colors. Yellow seen against blue is not the same as yellow seen against green, and it is in the subtle intricacies of color interaction and color relationships that photographs can acquire the power to attract, intrigue, and challenge.

As in so much else related to color, the dynamics of these relationships operate at different levels of perception and psychology. There are optical effects generated by the retina, and others created deeper in the visual cortex, while overlaid on these are all kinds of acquired likes and dislikes. One of the most vexed areas of color discussion is that of harmony and discord—colors that are considered to fit well together, to complement each other, versus those that breach an assumed code of approval. This is about taste, fashion, and acceptability, and is ammunition for colorists, whether painters or photographers, to make images that please or displease.

The majority of art, with photography more complicit than most other forms, has been in the service of attractiveness, and this is no surprise. Nevertheless, photography has purposes other than

showing things at their most pleasant, and managing color relationships can be a part of this. Another feature of colors as they are found in life, especially in the natural world, is that they inhabit a more subtle, less pure space than the primaries and secondaries that we saw in chapter one. Differences of hue are less extreme than the color circles and swatches available in editing software. Earth colors, the complex range of plant-life greens, pastels, and metallic colors all have their own beauty, less insistent and more finely shaded.

GOLDEN HOUR

Golden-hour light on warm stone contrasts beautifully with a clear blue sky. This combination of yellow and blues tones is a classic.

Color Relationships

Colors are never seen totally in isolation, and two different colors side by side will each react to the presence of the other. Ultimately, this is a matter of contrast of one kind or another.

Even when describing single colors alone, it is impossible to avoid their settings, as we have seen in chapter one. The energy of any hue changes significantly as it moves from one background to another—as from white to black, for example. This happens in two ways: the characteristics of each color are altered, and the combination itself creates visual and expressive effects. Our perception of colors changes according to their context.

Ultimately, despite the inherent qualities of a hue, the total effect is determined by contrast. Contrast—and I draw here heavily on the teaching of Johannes Itten at the Bauhaus—is at the heart of design. We can be specific about this, and identify several different types of color contrast, which we will cover in detail in this chapter. For now, the principal color contrasts are:

Contrast of hue
That is, combinations of the hues that have been individually described on pages 34–59, and their relationships across the color circle.

CONTRAST OF HUE

Opposite. In certain lighting conditions the flamingo can appear robustly red, here contrasting clearly with the blue water and the blurred green foliage in the background. This is an excellent example of contrast of hue, accenting the picture.

CONTRAST OF SATURATION

Above. A group of tribal women in India walk to a local well in the afternoon. Although their clothes are of similar hues—predominantly pinks and oranges—the variation in saturation creates contrast.

Contrast of brightness

Even though each color can be dark or light within a certain range, the standard pure versions vary between hues, from violet at one extreme to yellow at the other.

Contrast of saturation

As we have already seen, colors can be adulterated from pure all the way to gray. Usually, the contrast of a diluted color with a pure hue benefits the former; it gains life from the pure color, which itself loses energy.

Contrast of sensation

There is a sensory association between color and temperature, humidity, and even time of day.

Spatial contrast

As seems logical, the bigger the area of a color, the more dominant it is. Nevertheless, the contrast effects of size are more interesting when a strong color appears very small. It seems to fight more for attention, drawing the eye to it as a

SPATIAL CONTRAST

As we shall go on to see later in the chapter, orange is twice as luminous as blue, and so although blue covers a much greater area of this Chinese snuff bottle than orange, the fact that orange is more dominant creates a sense of balance between the top and the rest of the bottle.

Color combinations and relationships clearly do affect mood and aesthetic response, but no one has yet devised a way of quantifying this. As a result, pronouncements by painters, color theorists, and photographers have always been highly subjective, and inevitably contradictory.

Central to this is the idea of harmony and discord in color, which relies on the assumption that there is a kind of right and wrong. Not everyone agrees on this, but those who do tend to be dogmatic. There is a perceptual argument, based on successive and simultaneous contrast, as described on the following pages. How far you are prepared to take this is an open question. Harmony is widely, but wrongly, thought of as a description of similarity, arrived at subjectively on the grounds of appearing to be pleasing. In fact, harmony is a function of balance and equilibrium, which can include similarity but is more likely to be based on a particular contrast.

focus of interest. The position in the frame of the areas of color, and their shapes, also influence the nature of spatial contrast.

The following pages will be devoted to exploring the great variety of color relationships, and they extend from the perceptual through to the psychological. Some of the perceptual relationships can be tested and measured, which puts them on relatively safe ground. The psychological effects are another matter.

Color and mood

Many artists—painters and photographers—have had their own ideas about feelings and emotions expressed by color combinations. They remain heavily subjective. Here is one set of associations made by the painter and theorist Josef Albers, represented here as triangles:

1 Lucid
2 Serious
3 Mighty
4 Melancholic
5 Serene

1

3

2

4

5

Optical Color Effects

There are several important ways in which colors interact that, because of the psychology of perception, are not as most people would expect.

There is a set of phenomena that has to do with the way we process color in the visual cortex, and they have an important bearing on theories of harmony and discord—and so on the ways in which you can present colors in a photograph. The two most important of these are successive and simultaneous contrast, first identified by the French chemist Michel Eugène Chevreul in the 1820s. Successive contrast, also known as after-image, causes the eye to "see" the opposite hue immediately after looking at a strong color. Stare at the red circles for about a minute, focusing on the small cross in the middle. Then quickly shift your gaze to the cross in the center of the blank white square. You should be able to "see" circles of a different color—blue-green (the same effect occurs if, after looking at the red, you close your eyes tightly). This after-image is a reaction generated by the eye and brain; the effect is strongest with a bright color and when you have stared at it for a long time. The significance of successive contrast is that the after-image colors are always complementary, meaning directly opposite on the spectral color circle.

The companion effect to successive contrast is simultaneous contrast, in which one color, juxtaposed with another, appears slightly tinged with the complementary of the second. This is at its most obvious when a neutral appears alongside a strong, pure hue, as seen in the illustrations the photographs on page 112. In other words, a patch of gray on a background of a single hue appears tinged with the opposite color. Although much slighter, this same contrast occurs between two noncomplementary colors; each seems tinged just a little with the opposite.

LOBSTER

A practical application of optical effects is the choice of background, where the tendency of the eye to compensate for a distinct color alters the perception of the object, in this case a cooked lobster. In four extreme examples (extremes of brightness and of color contrast with the lobster), the color appears to differ, particularly between the green background (a redder lobster) and the lobster-colored background (less red).

Simultaneous contrast

One of the most well-known and important optical effects, in which the eye tends to compensate for a strong color by "seeing" its complementary opposite in adjoining areas. The classic demonstration is a neutral gray area enclosed by a strong color. The gray appears to take on a cast that is opposite in hue to that of the surround. Gray surrounded by green takes on a slight magenta cast; gray surrounded by red tends toward cyan. The phenomenon also affects nonneutral areas of color, as the violet and purple pair illustrates. The central squares are identical.

SIMULTANEOUS CONTRAST
Here is a practical example with a real image. The silver fittings of this old cape with a coat of arms acquire a different cast according to the color of the cloth (the original was red).

Successive contrast

This effect is similar to simultaneous contrast in principle, but over a (short) period of time. That is to say, the eye reacts to the stimulus of a strong color by creating its complementary, but does so after exposure. Stare at the cross in the center of the red circle for at least half a minute, then immediately shift your gaze to the cross in the center of the white space below. You will see an after image that gradually fades—and the color is cyan. If the circle were green (you can try this for yourself by making one in Photoshop) the after-image would be magenta.

CIRCLES EFFECT

A variation of this effect includes the white ground. Stare as before at the small cross in the center of the left box. After at least half a minute shift to the right cross.

Bezold effect

A color illusion related to simultaneous contrast, but with an opposite effect, was identified by the German meteorologist Wilhelm von Bezold, and is a kind of color assimilation. Demonstrated by the color theoretician Josef Albers with a red-brick pair of images similar to the photograph here, the presence of a light color (white mortar) appears to lighten the red of the bricks when compared with the darkening effect of black mortar. It is as if there is an optical blending taking place.

Purkinje shift

Named after the Czech physiologist who described this phenomenon in 1825, this effect occurs at dusk, when the eye's scotopic system (light-insensitive rods) begins to operate yet there is still enough light for the color-sensitive cones in the photopic system to work. The photopic system is more sensitive to longer wavelengths (reds and yellows) while the scotopic system is more sensitive to shorter (blues and greens). At dusk, therefore, reds and yellows appear darker than they were, and blues and greens lighter.

Vanishing boundaries

This is the opposite effect from vibration, in which equal brightness between different colors can make the edge between them seem to disappear, or at least be hard to distinguish. This is sometimes visible with cumulus clouds that vary from white to dark gray against a blue sky—there is a mid-point at which sky and cloud seem to merge.

Interrupted color

This effect has some similarities with simultaneous contrast, but derives its power from the presence of intense colors that interrupt the smooth perception of a single bar of color. Although the eye remains convinced that the two pale bluish squares in the right image are different, removing the strong blue and yellow bands, as in the bottom image, proves that they are exactly the same.

Vibration

Vibration is one of a family of flicker effects that had their moment of glory in the 1960s with the popularity of Op Art, notably by artists Bridget Riley and Vasarely. Arrangements of lines, dots, and patterns can be made to produce various kinds of motion and, at the same time, odd color shifts, most of which are uncomfortable to look at for long. As the art historian Ernst Gombrich wrote: "I admire the ingenuity and enjoy the fun of these demonstrations, and I realize that the artists cannot be blamed if we find them somewhat marginal in importance."

Vibration occurs along the edge between two intense colors that contrast in hue but are similar in brightness. Red is the easiest color to work with because of its richness and its medium brightness and, as the illustration here shows, the effect is powerful. The edge seems to be optically unstable; if you stare at it for long enough you can see a light and dark fringe. This optical vibration makes such pure combinations unsettling to look at for long, even irritating. The key is that the two neighboring hues have the same luminosity and a sharply defined edge.

RAINBOW ZEBRA

Applying the vibration effect to a natural pattern, the
dark stripes of a zebra have been given a gradient of
primary colors. If the white spaces were to be lowered
in brightness, to a gray, the optical flicker would be
even greater.

Harmony

There is a strong argument for arrangements of color that are likable, and it can be justified in terms of the color circle and the placement of colors around it.

The idea that certain combinations of color are harmonious—that is, inherently satisfying to look at—is a persistent one. Painters, designers, and colorists in general have usually approached this from a gut instinct, but there is some theory behind it. Art historian John Gage identifies four classes of harmony theory: the analogy with music (harmonic scale), complementary harmony (opposites on the color circle), similarity of brightness/value, and experimental psychology (based on the reactions of test subjects). In addition, there is similarity of hue (a group of colors in one image from the same sector of the color circle). Ultimately, harmony is a conservative view of color that conforms to expectation. It is safe and comfortable, which is fine if you want images to be beautiful, but its opposite, discord, also has a role to play in art and photography. Generally these theories work, but the implication that images ought to be harmonious is a little dangerous. Nevertheless, we'll look at the combinations that most people find pleasing.

One clue to the way in which harmony can work lies in successive contrast: the after-image. By supplying an opposite color, the eye is, in effect, restoring a balance. This is one of the main principles of virtually all color theories: that the eye and brain find color satisfaction and balance only in neutrality. We should qualify this by saying that an actual gray does not have to be present, only colors that would give gray if combined. One argument is that the eye and brain appear to mix the colors received. This is where the color circle really comes into its own. Any two colors directly opposite each other on the circle give a neutral result when mixed. Such pairs of colors are called complementary, and their combination is balanced in a way that can be tested, as we saw just now with successive contrast. It was Goethe who observed that the eye compensates for one strong color by creating its complementary as an after-image. We can take this further. Any combination that is symmetrical around the middle of the circle has a potential blend that is neutral and, therefore, balanced. So, three evenly spaced colors like the primaries yellow, red, and blue make a harmonious group, as do yellow-orange, red-violet, and blue-green. Sets of four colors can also be harmonious, as can intermediate and unsaturated hues.

COMPLEMENTARIES ACROSS THE CIRCLE

Using the color circle opposite, harmonious color relationships can be worked out very easily. The only requirement is that the colors used are arranged symmetrically around the circle's center. Given this, pairs and groups of three, four, and more produce a sense of balance.

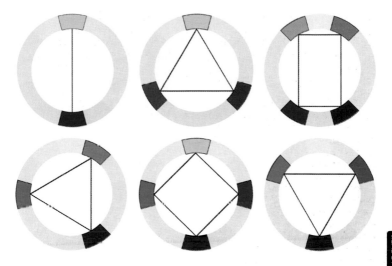

COLOR CIRCLE

A color circle, as used in the complementary color examples, with the colors visible.

Chevreul, the man who discovered simultaneous and successive contrast (pages 109–11), took his results further than just proclaiming a law of perception. He made an aesthetic judgment: "In the Harmony of Contrast the complementary assortment is superior to every other." This assumption has been repeated many times since, and the optical effects that he found give it some justification.

Brightness comes into the equation. It is not quite enough to say that certain pairs and combinations of colors are harmonious. Each color has an intrinsic brightness, so complete balance requires that the combinations be seen in certain proportions. In photography, this is complicated by the details of texture, shape, and so on. The color in images is enmeshed in the structure of the subject. As a start, however, we can look at the

BRIGHTNESS & PROPORTION

Even without considering complementaries, a combination of dark and light tends to look more harmonious when the framing takes this into account. As always, however, harmony is not a rule, and is only one component in an image.

basic combinations of primaries and secondaries introduced in chapter one. The complementary for each primary color is a secondary: red/green, orange/blue, yellow/violet. However, we have already seen something of the differences in brightness among these six colors, and the strength of each in combination follows this. In descending order, the generally accepted light values, originally determined by the German poet and playwright J.W. von Goethe, are yellow 9, orange 8, red and green 6, blue 4, and violet 3. When they are combined, these relative values must

COMPLEMENTARY PROPORTIONS
ADJUSTED FOR BRIGHTNESS

Using the relative brightness of pure colors explained in
the text, the balanced combination of complementaries,
and of the basic three-color sets, looks like these
individual blocks.

be reversed, so that violet, for example,
occupies a large enough area to make up
for its lack of strength. The areas needed for
these colors are, therefore: violet 9, blue 8,
red and green 6, orange 4, and yellow 3.

The color blocks on page 117 illustrate
the ideal balance proportions of the three
complementary pairs and the two sets of
three. Other combinations can be worked
out in the same way. For simplicity and
continuity, the proportions shown here are
for pure standard hues, but the principle
applies to any color, whether intermediate
on the color circle, a mixture, or poorly
saturated. The brightness or darkness
of the hue also affects the proportion.

There is a very important caveat
to this principle of color harmony. You
can apply it with complete success,
but its foundation is the psychology
and physiology of perception and no
more. Used precisely it has something
of a mechanical, predictable effect, and
what you gain in producing a satisfying
sense of equilibrium you are likely to
lose in character, interest, and innovation.
Color harmony can show you how to make
an image look calm and correct, but it is
hardly conceivable that anyone would
want all or most pictures to generate this
impression. You should know the base-line

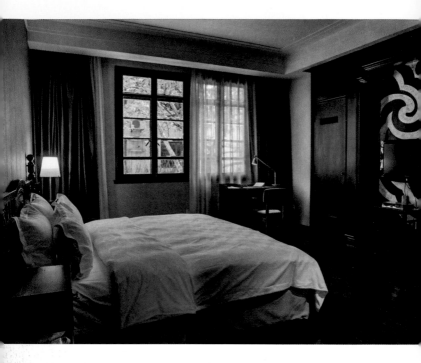

of color harmony, but only as a foundation. Good use of color involves dissonance and conflict where appropriate.

A different approach to harmony is unity through similarity, which essentially means choosing a set of neighboring colors. These could be neighbors in hue—all from one side of the color circle—or else modulations in saturation or brightness of a tighter set of hues. There is a long history in art of achieving a gentle, pleasing range of colors in this way. Art historian Kenneth Clark made the

HARMONY BY SIMILARITY

Choosing a range of colors that are all adjacent on an arc of the color circle ensures a comfortable relationship between them as shown here in the KeTangJian boutique hotel in Shanghai.

analogy that colors "close together have a spectacular beauty—they are often like the faintly shadowed vowel sounds so often a source of magic in verse."

Mixing with blur

One highly characteristic feature of photography is optical blur—a gradual softening and mixing of the image away from the distance at which the lens is focused. Gradated focus is even considered to make an image "photographic," and received attention from Photo-Realist painters beginning in the 1960s. In terms of color, defocusing blends hues, as these images show; this apparently natural optical effect has itself a harmonizing property, whatever the colors.

Red & Green

This combination of the strongest hue (red) and the most common in nature (green) is frequent and powerful, although the most balanced mixture uses a bluish green.

Pure red and pure green have the same luminosity, and so combine harmoniously in equal proportions. This, however, presupposes that both colors are pure and exact, though of course this rarely happens, and in practice there is little point in measuring the areas precisely. Indeed, although both red and green have the wide ranges we saw in Optical color effects (pages 108–15), the actual perceptual complementary to red is closer to cyan than to green. In nature, red/green combinations are mainly limited to plantlife; although green is abundant in many landscapes, red is much less so. An

early *National Geographic* cliché was a red-jacketed figure in a landscape, as a simple means of drawing attention, and many photographers will seek to include an area of red in an otherwise largely green image, simply to draw the eye.

Red and green, when they do have the same luminosity and are saturated, exhibit the color effect known as vibration, introduced on page 114. Irritating though it can be when you look at it for a period of time (and problematic for some types of TV screen and computer displays for that matter), the effect is eye-catching and dynamic, and greatly enhances the energy of an image. To some extent it occurs between any two brilliant colors, but nowhere is the effect as strong as it is when red is involved, and it happens most distinctly between red and green.

RESTAURANT SIGN

Right: The glass wall entrance to a Thai restaurant created by a Japanese designer in Tokyo features a subtle pairing of the two colors for a delicate effect.

JACARANDA

Above: On the margins of red, in the direction of mauve and purple, this lone flowering jacaranda tree in the Amazon rainforest nevertheless creates an image that draws on the red-green principle of harmony.

BERRIES

Below: A spriy of glossy red berries in the dappled woodland of New Brunswick appears all the more intense for being surrounded by green.

As you might expect, changing the proportions weakens the harmony. However, when the balance is extreme, the smaller color acquires extra energy. As you can see in the photograph on page 104, the strong red color of the flamingo, far from being overwhelmed by the green of the fields (and the blue of the water), draws attention to itself insistently. Instead of a color combination, we have a color accent. The effect is stronger when red is on a green or blue background than vice versa, because of the tendency of warm colors to advance while cool colors recede.

Orange & Blue

Of the three classic color harmonies, orange/blue is probably the easiest to find photographically, because both colors are close to the color temperature scale of light.

Orange is twice as luminous as blue, so that the best balance is when the blue is twice the area in a picture. Compared with red/green combinations, this makes for less optical confusion about which color is the background. It also drastically reduces the vibration, so that orange and blue are generally more comfortable to look at. The German expressionist painter August Macke described blue and orange as making "a thoroughly festive chord."

Orange and blue lie very close to the opposite ends of the color temperature scale, so that they can be found in many common lighting conditions. A low sun, candlelight, and low-wattage tungsten light bulbs are some of the sources of

BUDDHA & FLAME

Using selective focus to combine this classic pair of colors, a blue-clad Buddha image in Koyasan, Japan, was photographed through the flame from a candle burning in front.

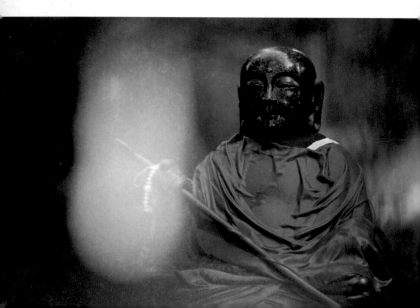

Reverse proportions

An interesting exercise, and one that's easy to perform digitally, is to reverse the proportions between the two colors. As shown here, make a duplicate layer and shift all the hues 180° using the *Hue/Saturation* control on Master. Then erase those areas from the upper layer that you do not want to alter—in this case, the faces of the girls.

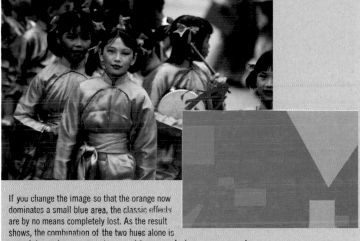

If you change the image so that the orange now dominates a small blue area, the classic effects are by no means completely lost. As the result shows, the combination of the two hues alone is enough to produce a general sense of harmony. And, as you can see from the examples of color accent on page 134, the eye is drawn to the smaller area of color. In focusing just on this part of the image, the eye receives a local impression that is more balanced, with the blue seeming more powerful than its area merits.

orange—not pure, but close enough. On the other hand, a clear sky, and the light from it, is a ubiquitous blue. At sunrise and sunset, therefore, there is a natural complementary effect from the orange sunlight on the one side and the blue shadows on the other (and it was Leonardo da Vinci who appears to have been the first to notice this). As well as contrasting in brightness, orange and blue have the strongest apparent cool/warm contrast of any primary or secondary pair of complementary colors. This produces an advancing/receding impression and, with the appropriate setting, a relatively small orange subject stands out powerfully against a blue background, with a strong three-dimensional effect.

METAL SHUTTER

Above left: A modern house in Ahmedabad, India, uses a range of primary colors in its decoration, including these handmade metal shutters.

HAVELI

Above: An old courtyard house, or haveli, in the Rajasthani city of Bikaner, freshly painted in a pastel variation on orange and blue. The individual hues on the four images here are all different, but the combinations work visually in the same way.

SHIP PAINTING

Above: A Greek fishing boat being painted. The expanse of blue hull, greater than seen here, and a clear space made it easy to choose a telephoto setting to refine the proportions of the two colors.

INDIGO

Left: Indigo, a modern Indian restaurant in Colaba, southern Mumbai, features a skylight allowing light to stream into the interior pool, bathing the dining area in a changing play of hues.

Yellow & Violet

The third combination contrasts the brightest and darkest colors in the spectrum, with intense results, but the rarity of violet makes it an uncommon relationship.

This third complementary pair combines the brightest and darkest of all the pure hues. As a result, the contrast is extreme and the balanced proportions need to be in the order of 1:3, with the yellow occupying only about a quarter of the image. At these proportions, the yellow is almost a spot of color, and the sense of a relationship between the two is correspondingly weak.

The relative scarcity of violet in subjects, and settings available for photography, makes yellow/violet an uncommon combination, particularly as in the ideal proportions the violet must occupy a large area. One of the few reliable natural combinations is in flowers; the close-up of the center of a violet is a classic example.

SIENA PALIO

Below: Parades during the Tuscan city of Siena's annual Palio horse races. The camera position was chosen to include all the components, and it also gives the opportunity to play with the yellow and purple color combination over the gray buildings.

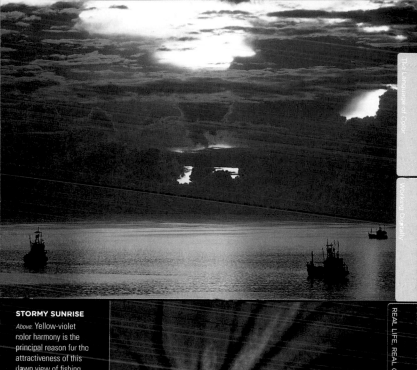

STORMY SUNRISE

Above: Yellow-violet color harmony is the principal reason for the attractiveness of this dawn view of fishing boats in the Gulf of Siam. Even though the two hues are pale, the harmony is persistent, and contributes to the calm, placid feeling. The contrast of hue has been deliberately enhanced, as shown on pages 180–81, Selective Enhancement.

FLOWER

Right: The very center of a violet flower contains this color harmony. By closing in with a macro lens, the proportions can be adjusted.

Multicolor Combinations

Relationships between three and more colors in one frame become complex, and depend on strength of hue to remain significant.

The more colors that appear in a scene, the less likely they are to remain distinct as color masses. At a certain point they merge perceptually into a colorful mosaic and lose their individual identity. Several small areas of the same color do not necessarily add up perceptually to one single mass, and in real life there are limited occasions for finding even a three-color scene that is distinctive. Naturally, selective digital enhancement can help improve the relationship.

While red-yellow-blue is the most powerful mixture of pure hues, other less well-balanced combinations of color can have similarly impressive effects. As you can see from the pictures on these and the following two pages, there is a major difference between groupings of strong, bold colors and those of delicate, pastel

CUZCO

Below. Three color-coordinated Peruvian children crossing the square in Cuzco.

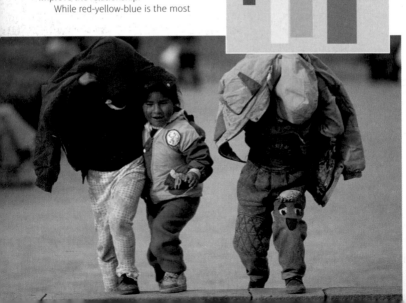

PAINTED PRAHU

Left: Although they are set among other mainly neutral hues and scattered over the image, the intensity of the three pure primaries punches through to dominate this image of painted Balinese fishing boats. No other color combination has quite the same power and intensity, even in small quantities.

PASTEL HARMONY

Left: Even though the colors in this house-painting scene in northern Sudan are not precisely equilateral, they are close enough for a harmonic relationship because they are essentially pastels —paler versions of the basic hues.

shades. Pure hues fight intensely for attention, and the strongest combinations are those of three colors. Even a fourth introduces excess competition, so that instead of building each other up, the colors dissipate the contrast effects.

Wherever you can find groups of pure colors, they make easy, attention-grabbing shots. Being unbalanced in their positions around the color circle, they do not mix to gray in the visual cortex, and so contain the element of tension missing from the primary and secondary mixes on page 116. Considered as part of an overall program of shooting, strong color combinations are the short-term, straight-between-the-eyes images. They fit well into a selection of less

intense pictures as strong punctuations, but several together quickly become a surfeit.

We can extend the balancing principle of complementary pairs to three and more colors. Going back to the color circle, three equally spaced colors mix to give a neutral color (white, gray, or black depending on whether light or pigments are missed). The most intense triad of colors is, as you might expect, primary red, yellow, and blue. The color effect in a photograph depends very much on how saturated they are and on their proportions: equal areas give the most balanced result.

ENHANCING TRIPLE HARMONY

Increasing the saturation appropriately will make color relationships more distinct—though at the expense of subtlety and other image qualities. As an excrcion, this image of a Shaker schoolhouse, already quite rich and sharply lit, has been given even greater saturation using editing software. The building itself, already neutral, is hardly affected, but the surroundings resolve themselves into a grouping of primary colors.

Three-way balance

Evenly spaced around the color circle, the three primary (painting) hues form an equilateral triangle. Together they cancel each other out, mixing to produce neutral gray. Also evenly spaced around the circle, the secondary hues balance each other in exactly the same way as the primaries.

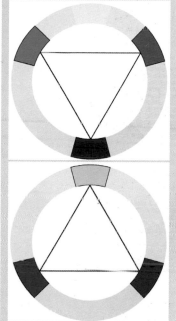

Color Accent

A small area of bright color set somewhere in the frame and contrasting with the background is a special case in color relationships with a particular relevance for photography.

If we accept the idea of harmony as having some basis in the physiology of perception, with a tendency for the eye to seek some sort of balance, then it's easy to see how composition in photography naturally drifts toward certain proportions between masses of color in a scene. The harmonious proportions that we looked at on the previous pages represent a higher comfort level than most. It does not, of course, make them in any sense better.

SILVER CHARIOT

One of the daily events in a Jain temple in India is the parading of silver chariots and, while this is the real subject of the photograph, the use of two color accents enlivens it. The separation of the yellow and blue greatly reduces the significance of proportions.

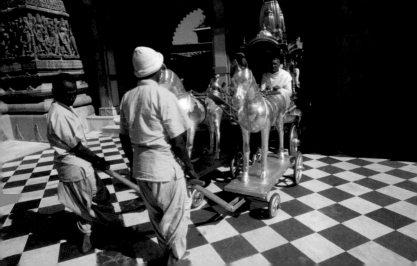

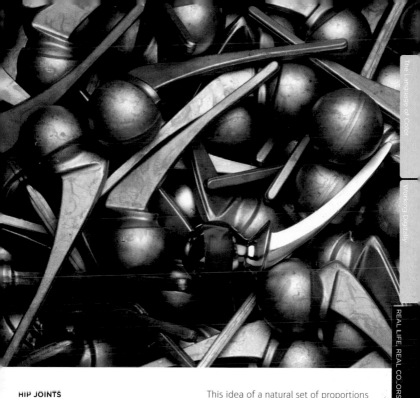

HIP JOINTS

Here the red accent color, on one of a number of artificial hip joints, stands out from an entirely neutral background.

This idea of a natural set of proportions has a particular relevance in photography because so much of what we shoot is "found." Faced with a scene that appears to have the potential for a successful image, the usual tactics for composition involve closing in or pulling back, altering the zoom and moving the frame, and the proportions of color brightness influence this to a greater or lesser degree.

Yet when there is an extreme difference in proportion between colors—meaning when one at least is very small relative to the frame—the dynamics

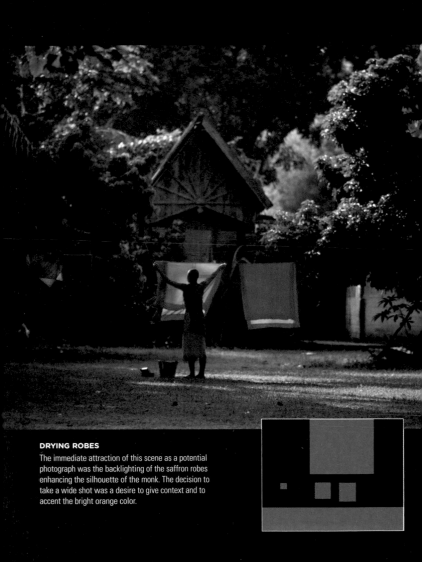

DRYING ROBES

The immediate attraction of this scene as a potential photograph was the backlighting of the saffron robes enhancing the silhouette of the monk. The decision to take a wide shot was a desire to give context and to accent the bright orange color.

become those of a point within a field, the equivalent of a black dot on a white background. The proportions become, in effect, irrelevant. One color becomes an accent, or spot color, and the eye is very much pulled and directed by its placement. When the accent color "advances" from a "retreating" background, the effect is at its strongest—as in yellow/red or blue/green. Paradoxically, perhaps, under certain conditions the very localization of a small color accent gives it more perceptual strength.

Because of the small areas involved, it is possible to have spot color combinations in which there are two or more different accents. This complicates matters because the two spot colors have a relationship between themselves as well as with the background. The most distinct effect is when the setting or background is relatively colorless and the two purer hues occupy localized areas. This effect was used by painters such as Delacroix and Ingres to promote harmony through variety in some of their paintings. They used scatterings of complementary colors such as blue and orange, and red and green.

This special form of color contrast inevitably gives greater prominence to what painters call "local color," the supposedly true color of an object seen in neutral lighting, without the influence of color cast. Color accents, above all, stress object color.

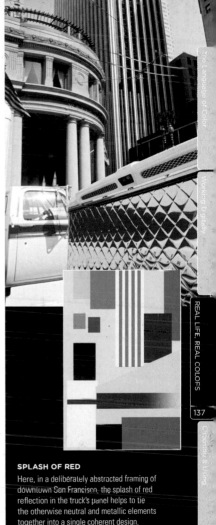

SPLASH OF RED

Here, in a deliberately abstracted framing of downtown San Francisco, the splash of red reflection in the truck's panel helps to tie the otherwise neutral and metallic elements together into a single coherent design.

Discord

The negative of harmony is discord. Equally subjective, dependent on opinion, and liable to change, it has its own terminology, with terms such as "clashing," "strident," and "vulgar."

Just as the concept of harmony (page 116) is loaded with personal and cultural values, so its counterpart, discord, assumes a raft of opinions and prejudices. Moreover, the major underlying assumption is that there are combinations of colors that must somehow offend. This is not at all safe and yet, as with harmony, there is some truth in this, partly perceptual, partly cultural, and partly to do with fashion.

By definition, colors that clash cannot be from the same region of a color model. They must be distinctly different, yet without the optical connection of being complementary. This means that at least one of the colors needs to be strongly saturated. Also, any optical effect that is uncomfortable to look at can enhance discord.

Beyond these fairly basic optical and perceptual principles, discord depends on cultural values, and also fashion. Culturally, the element of disapproval is strong, as you might expect, because colors that are thought to clash are in some way at odds with whatever is safe, undemanding, and conservative. Whether in choice of clothes or in interior decor, it raises the issue of good taste versus bad, where there are no absolutes. Possibly the most common use of clashing colors is in advertising, as attracting attention overrides any questions of taste.

In art, discord is typically used to challenge assumptions, awaken the audience's attention, and make statements. Kandinsky made this point

CARNIVAL

Left: Carnival in Kingston, Jamaica is an occasion for an excess of energy, not only through music and dance, but visually. The whole idea is to be bright, not restrained.

JINR APARTMENT

Opposite: Converted and decorated by Chinese architect Jiang Tao, the aim was to create a spacious feel to a small apartment, with idiosyncratic touches of vibrant color.

forcefully in his *On The Spiritual In Art* in 1911–12 when he wrote that: "harmonization on the basis of simple colors is precisely the least suitable for our time . . ." going on to proclaim that: "Clashing discord . . . 'principles' overthrown . . . stress and longing . . . opposites and contradictions . . . this is our harmony." Earlier, in *The Night Café* (1888) Van Gogh used discord to communicate what he wrote of as a place where one could go mad: "I have tried to express the terrible passions of humanity by means of red and green . . . Everywhere there is a clash and contrast of the most disparate reds and greens." This may sound at odds with red-green harmony, but he chose greens that tend toward a livid yellow.

JAPANESE KITSCH

A dispenser selling cuddly toys on a Japanese city street. Pink is one of the favored colors of a deliberate kitsch, its garishness enhanced by the green glow of fluorescent striplights.

Deliberately offending is also a staple of conceptual art, and it has the same possibilities in photography. To date, however, there have been few photographers who have made any notable use of clashing colors, and the reasons are not hard to find. Before digital, choosing colors in photography meant finding them in real life and composing to fit. As discordant colors tend to be avoided when most people are making color choice, they are not common. British photographer Martin Parr is one of the

TEEJ FESTIVAL

In this annual celebration, a line of Nepalese women exhibit a vibrant clash of brightly colored saris. Discordant, certainly, but also full of energy.

few who have made a signature of this kind of color combination because it is an integral part of his preferred subject matter—the vulgarity of the British on holiday.

Digital imaging allows such choice of color to be made by the photographer independently of the subject matter, if wanted. Individual colors can be enhanced, shifted, or, if necessary, completely replaced. This is still an under-explored area. Like everything else in color choice and manipulation, there needs to be a

sound reason, and more conspicuously so if the aim is to increase visual discomfort.

Notionally the opposite of harmony, discord is, if anything, more problematic because of its negative connotations. To say that two or more colors in combination are discordant—that they "clash"—is to suggest that there is something wrong about the choice. Just as there is an underlying assumption that harmony is generally a good thing, the idea of discord carries with it the sense that it is better avoided. These are clearly dangerous assumptions, if only because they rest on the idea of an established order.

Color & Sensation

Color contrast resulting in a kind of harmony can also occur between groups of colors that evoke other sensory experiences, such as heat or dryness.

There are natural associations between physical sensation and color. The strongest, and most natural-seeming, of these is between temperature and color, but wet/dry and day/night contrasts are also powerful. Flame and things glowing with heat are either orange, or close to it on either side on the color circle (that is, yellow-orange, or toward red). The hottest color as perceived by most people is, in fact, orange-red. Its complementary, opposite on the color circle, is blue-green, and this gives the coldest effect (these temperature associations are real; a room decorated in shades of blue-green does feel physically colder than one in orange-red, even if both are identical in temperature). The contrast between sunlight and blue sky, which is also the contrast between sunlight and shadow, occurs everywhere, and when the sun is low it is exaggerated. At dusk, the colors in the direction of the setting sun are warm; in the opposite direction they are cool. Twilight gives a particularly cool background. Artificial lighting produces even stronger opposites. Tungsten lighting is yellow-orange on daylight-balanced film, and the lower the wattage and the dimmer the lamp, the more orange it appears. Fluorescent lighting appears greenish to blue-green.

Most of these are color temperature effects, and it is important to understand the differences between this scale and the cool/warm contrast of the color circle. They

The sensory color poles

Three different sensations depend on dividing the color circle along different axes. The light-dark split of the color circle is centered on yellow and violet respectively, the cool-warm division between blue-green and orange-red, while wet-dry are cyan and orange-red.

BLUE DAWN

A fishing boat comes into harbor in the Bay of Fundy, New Brunswick, Canada in the early morning. The light is suffused with a blue tint giving a distinct impression of cold.

are similar, but not identical. For instance, the color temperature scale goes from hot (orange) through white hot to extremely hot (blue). This is physically accurate, but outside our normal experience. On the contrary, we associate blue with cool things, not with extreme heat. The second difference, a small one, is that the range of color temperature is not along a scale of pure color; both the orange and blue at either end are a little dull in comparison with those of the color circle.

Color is also linked to humidity, with "hotter" colors and those associated with aridity, sand, and dust evoking dryness, while greens and blues naturally suggest water and wet vegetation. Finally, brighter colors can be thought of as colors of daylight, as opposed to the darker ones related to evening and night. The validity of these opposed sensations relies on dividing the color circle in half. These are polar opposites in groups rather than in single hues. The contrasts can effect other associations, such as the suggestion of distance. Because cool colors recede and warm colors advance, blue-green and its neighboring colors are associated with backgrounds and distance. If the color of a subject is warm, and that of its background cool, the impression of depth is heightened. This is a different depth sensation from the one created by light/ dark contrast, but if the two are combined (a pure orange against a deep blue, for example), the impression is slightly stronger. As a result, a small area of a warm color set in a larger cool-colored frame always looks appropriate Another association, also related to our experience, is that pale cool colors suggest transparency and airiness. This comes in part from the blue color of a clear sky, and in part from the pale blue of things seen at a distance through atmospheric haze.

THE COLOR OF DAMP

Opposite: A ruined gallery at a 13th-century temple in Angkor Wat. The range of colors on a cloudy day, from green to blue-green, evoke damp, creeping moss, and dripping stones, in a humid atmosphere.

SHAKER BOX

Right: As the sun sinks toward the horizon, the light becomes more orange. Its rays pass through more atmosphere and this filters out the cooler colors—the shorter wavelengths— by scattering.

Warm colors

Close to sunset, the sunlight becomes more orange. The closer the sun is to the horizon, the more atmosphere its rays pass through, and this filters out the cooler colors—the shorter wavelengths—by scattering. This is progressive, like the absorption of warm colors by water; as the sun sets, the color moves from white to yellow, and then toward orange and red. Atmospheric conditions determine the exact color.

Cool colors

Underwater views always appear cool because of the selective absorption of light. Although the sunlight striking the surface of the sea is virtually white—a mixture of all the colors of the spectrum—water absorbs the spectrum progressively. That is, as the depth increases, more of the spectrum is lost, from the red end toward blue. At about 20 feet (6 meters) in clear water, all red and orange has been absorbed, leaving only the cool colors.

Muted Colors

The majority of colors facing the camera in the real world are very far from pure, and while the impact is less, the subtle variations can be very enjoyable.

In traditional color theory, the pure colors have prominence, and painters are trained to construct hues from the primaries and secondaries. In contrast, photography deals almost exclusively with the range of colors found in the real world, and its color priorities are consequently different. As we have seen through cataloging the principal hues, they are not particularly common in nature. Most found colors can be seen as "broken;" that is, they are seen as a mixture of hues that

ROAST SUCKLING PIG

Brown, here in a rich, reddish form on the glazed skin of spit-roasted pork in a popular restaurant district in Manila, is the most well-defined of all muted colors. Others, such as drab greens, are variations of more saturated hues, but brown is always under-saturated.

CAEN HILL

A remarkable flight of locks in the English canal system.
The extremely diffuse light of a dull day is ideal for this
image, allowing the geometric succession to dominate.

gives a deadened, unsaturated effect.
Such muted colors are, however, very
rewarding to work with, because of
the great variety of subtle effects. Color
theory gives an artificial stress to the pure
primary and secondary colors, as these
are the foundations of all other colors; it
would be a mistake to infer that pure hues
are inherently more desirable in a picture.
The differences between soft colors are
on a much narrower range than the pure

colors, and working constantly with them
trains the eye to be more delicate in its
discrimination, and to prize rare colors.
Russet, sienna, olive green, slate blue—
these and an almost limitless variety
of others, including the chromatic grays,
make up the broad but muted palette of
colors available for most photography.
Darkness, as in shadow detail, is
necessarily devoid of strong color, as the
Dutch tenebrist painters such as Rembrandt

PASTELS

Above: Faded denim jeans, a pale blue top, and a yellow Samba dress have a pastel effect during "Brazilian day" on the streets of Paris.

and Frans Hals discovered. These "painters of shadows" excelled at their handling of the lower tonal range by using palettes that were almost monochromatic. This takes us back to the chromatic neutrals that we saw on pages 72–73.

At the other end of the brightness scale are pastel colors. These, from a painter's point of view, are created by adding white rather than gray or black, so that they are never muddy in appearance, but rather soft, delicate, pale, and light. Pastel colors retain a hint of the purity of the original hue from which they derive, without the strength.

JAIPUR BALCONY

Above: A gentle combination, though colorful, of shutters and a balcony in the Rajasthan city of Jaipur. As with the shot on page 148, this is an example of pastel color.

VICTORIAN GRANDEUR

Right: The old St. Pancras Hotel in London, before restoration. The faded, warm colors of the main entrance lobby give the expected atmosphere of musty age, as if untouched and unvisited.

Case Study: **Brown**

If you are taking a set of pictures that are intended to be displayed together, there may well be an advantage in linking them graphically. There is hardly ever any point in trying to force this, but one opportunity that sometimes arises is color. The subjects may have a particular range of hues, or, quite commonly, the setting may have certain colors characteristic of it.

DUST STORM

Below. Girls returning from the water spring in single file protect their eyes from dust whipped up by the wind.

HEADDRESS

Right. Two Akha women wearing the traditional headdress that features silver balls sewn into the fabric.

BUFFALO

Above. At the end of the day, water buffalo return to the village from a day's grazing.

IRRIGATION

Below. A girl uses a leaf strategically placed to divert water from the bamboo aqueduct that runs from a spring.

Case Study: **Flesh Tones**

Flesh tones are rightly considered the memory colors par excellence, on the grounds that almost everyone can spot even a slightly wrong color shift. And yet there is a seeming paradox in that the full range of human flesh tones is enormous. Not only that, but it divides into a few quite different core groups—a question of anthropology, really. The actual case is that we best know the flesh tones that we see every day.

GRADIENTS

Above & left: You can use Photoshop's Gradient Editor to create a smooth gradient of the flesh tones present in a person's face for purposes of analysis. To access the Editor, just click below the gradient symbol in the top left of the screen when Photoshop is open. By default, there will be two color stops, one at each end of the gradient being displayed. Click the left-hand stop, immediately below the bar, then move the cursor over to the image of the face. It becomes a dropper. For consistency, click on a dark part of the skin. Then click once below the bar in the Gradient Editor to create a new color stop. Move back to the image of the face and select a different skin tone. Four or five stops should be sufficient, and it helps to progress from dark to pale, left to right.

FACES

Above: Here we take a number of portraits, optimized as much as is practical to create the semblance of consistent, neutral lighting. We can now analyze the colors by sampling different parts of each face. When you have finished, you will have a gradient map of the skin tones for that face, arranged linearly. Give your new gradient a name and click New to save it into the gradient collection. If you now open a new blank image file, choose the gradient you have just created and use the gradient tool to apply it.

GRADIENTS

Right: As you can see, even within any one face there are interesting differences in color. And with black skin, the environmental reflections really come into play, particularly with a blue sky. Between ethnic groups, the range of skin tones varies even more, as illustrated by the combination of these seven into one "color space." If accuracy of flesh tone is important to your photography, it might be worth constructing and adding to such a "flesh" color space yourself with every portrait that you shoot.

Iridescence & Metallic Colors

This special class of colored surfaces has in common a color and tonal shift that varies with very slight changes in the angle at which they are seen.

Iridescence is a spectral effect in which there seems to be a play of colors across the surface, and it changes with viewpoint and the angle of reflection. Diffraction, refraction, and interference effects play a part, and it appears in a wide range of materials and conditions, including oil slicks, soap bubbles, clouds, mother-of-pearl, stresses in plastic seen under

polarized light, and more. There are even specific terms for particular substances, such as pearlescence and opalescence. Interference occurs when trains of light waves interact with each other, often from the upper and lower surfaces of a transparent layer. There is a transience and impermanence about this, either to do with time or with angle of view. In either case, photography is uniquely well-equipped to capture it.

Metallic colors comprise another group that has its own unique characteristics. What distinguishes these colors is the special gradient of shading toward the highlights, and the extremely subtle shift of hue which accompanies it. In particular, metallic surfaces have a fairly high reflectivity and so pick up the tones and colors of their environment. As this is overlaid on the inherent color of the metal, the effects can be interesting and dynamic. Different metals have inherently different colors and degrees of reflection, which makes them recognizable as, for instance, gold, silver, lead, or aluminum. The type, quality, and direction of the light source make all the difference. If you have sufficient control to alter it, experiment with the variety of effects.

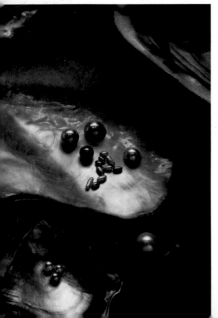

PEARLS

Left: A variety of gem-quality pearls at Tasaki Shinju, Kobe—Japan's largest distributor—arranged in shells. The lining of many mollusk shells is made of mother-of-pearl, or nacre. A form of protection, mother-of-pearl is made up of layers comprising both brittle and inorganic aragonite and elastic and organic material such as chitin and lustrin.

THAI SILK CLOTH

Right: The brocaded version catches metallic reflections, but the silk itself exhibits a shot effect, which has been exploited by the weaver in using different colors for the warp and weft. Gentle folding in both cases shows these effects to their best advantage.

In textiles, particularly silks, there is a technique of weaving in which the weft and warp, differently colored, are alternately dominant depending on the angle of view. Shot fabrics, as they are known, have a play of color that recalls iridescence. Capturing it in photographs relies on clearly modeled folds in the cloth.

GOLD

Above: A range of gold bars belonging to a London bullion dealer. Its unique color, reflective properties, and ductility have made gold an extremely desirable commodity over the centuries.

POLICE SHIELDS

Above: Bored police in Manila await the start of a demonstration. Their scuffed shields are in low-tech aluminum, which has a dull tone in the soft afternoon light.

SYNTHETIC THREAD

Right: A pattern of artificial fibers showing bright interference colors when seen through crossed polarizers.

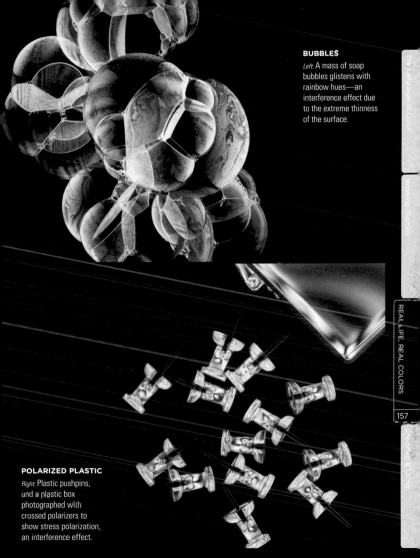

BUBBLES

Left: A mass of soap bubbles glistens with rainbow hues—an interference effect due to the extreme thinness of the surface.

POLARIZED PLASTIC

Right: Plastic pushpins, and a plastic box photographed with crossed polarizers to show stress polarization, an interference effect.

Case Study: **Images in Sequence**

In addition to the color relationships within an image, photographs are more often viewed in groups. Whether hung side by side as prints on a wall, facing each other in a magazine spread, or in sequence as a slide show, the color relationships between the several images impose their own structure. Sequence is involved however they are displayed, because the eye travels from one to another. All the principles of color interaction that we've looked at in this chapter apply, from successive contrast, to unity through similarity, to harmonious and discordant contrast.

MAGAZINE SPREADS

Because the units of color are entire images, the juxtaposition of photographs tends to favor those with a dominant color, as the example here illustrates. In this case, a fine example of skilled art direction with an eye to exploiting color, a 58-page story was constructed from several hundred photographs of India. The opening spreads of *Seven Seas*, an award-winning premium travel magazine from Japan, are shown here, reading from right to left. The images were selected and juxtaposed with color very largely in mind. In particular, the art director has made color work in the typography, and in the sequencing of the photographs.

第１章 混在す○進化と
　　　　　○伝統

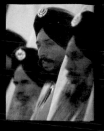

CHOOSING & USING

Using color, in the sense of exercising precise control, has traditionally been a problem for photography. Put simply, the means were limited. Black-and-white film photography, with its much more restricted range—tones without hues—offers plenty of scope for exactness and interpretation, and darkroom printing is the second phase of what can be turned into a long process, if so desired. Color film is less generous.

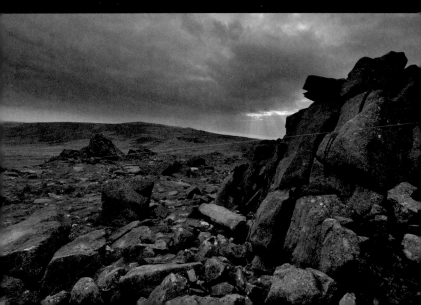

Two generations of photographers learned a kind of photography that, to all intents and purposes, ended when the shutter was released. Kodachrome and its successors allowed very little messing around during processing, restricted to pulling and pushing for quite small changes in brightness, always with unpleasant side effects on color cast, density, and graininess.

The only way of printing to high quality and with control from a color slide was the dye transfer process—highly complex and demanding, and in any case was eventually abandoned by its supplier, Kodak. Color negative film was more tractable, but still tricky to print well, and hardly intuitive.

Color control, then, depended with film on just two kinds of technique. One made use of the characteristics of the materials for whatever reasons they existed, such as the subtly different dye response in film. The other was—is—the organization of the scene in the viewfinder, a huge area of choice. This is no less relevant in digital photography, and remains the core skill. It certainly dominates the discussions in this book. And yet the different technologies of photography always play their part, and with digital capture and digital image editing there is suddenly a spectacular expansion in control and discrimination. The issues are not just what to do with this, but how to achieve a sensible balance between the taking of images and manipulating them.

HORIZON

The little splash of rose-tinged gold on the horizon contrasts nicely with the grays and charcoals of the rest of the image.

Color as the Subject

There is a clear difference between a photograph in which there happens to be color, and one in which the color works to make the image what it is.

This is a slightly dangerous area, full of creative pitfalls. At least, it's easy to attract criticism by attempting to discriminate between color and the physical subject. As we've seen, color excites opinion, and the very imprecision of the ways we have for talking about it means that there are many standards for judging it aesthetically. One area of dispute is to what extent color per se can legitimately be the subject of a photograph. And it really is a matter of opinion.

John Szarkowski felt that one of the two "categories of failure" of color

photography was concentrating on "beautiful colors in pleasing relationships" (the other was simple inattention—taking black- and-white pictures in color). I'm not at all sure that "beautiful" and "pleasing" are such bad qualities in a photograph, but they tend not to be highly regarded in art criticism. The point being made is that to be seduced by a swatch of paint may not be enough to justify an image. The result can be, as an art director friend,

TROOPING THE COLOR

Held annually to celebrate the Queen's official birthday, "Trooping the Color" is a parade of the seven regiments of the Household Cavalry and the Foot Guards in which red tunics and black bearskin headdresses feature prominently.

DRUNKEN REVELLERS

As part of the annual celebrations at the start of the hoped-for rains in northeast Thailand, participants paint themselves gaudily, and color is very much the subject.

Bob Morley, used to put it, "a picture in search of a subject." The terms may be a little vague, but the issue is real enough.

We can identify a scale of color importance ranging from images which could as well be, and may be even better as, black and white, through those that benefit from their color component, to some that exist because of color and without which would be pointless. The obvious test, and easy to perform digitally, is to convert the image to monochrome, in Photoshop either by *Image > Mode > Grayscale*, or by *Image > Adjustments > Desaturate*.

But who should say? Obviously the photographer, although color opinions tend, as usual, to be a free-for-all. Szarkowski's dismissive comment: "Most color photography, in short, has been either formless or pretty" refers to his idea of two alternative failings. In the first, "the problem of color is solved by inattention"

and the color content is "extraneous—a failure of form," a criticism only valid if the intention was to work with color. Magnum photographer Ian Berry once remarked to me that he photographed in black and white even when he was using color film (necessary for most magazine assignments). As a reportage photographer, he wasn't interested in the color. Not paying attention to color is not a failure, rather an attitude. But if you are attuned to color, the next precondition for a color-orientated image is finding it, and, just as good moments of human interaction happen only occasionally in reportage photography, interesting color combinations present themselves only from time to time—and whether they appeal or not depends on personal taste.

A Color Style

In the context of color, style means an identifiable palette and a way of handling it, but it carries the risk of being caught in a narrow niche.

Style in color, as in most areas of creativity, is widely considered a good thing to have—a sign of having achieved some kind of identifiable maturity. However, the definition has usually been vague. The tightrope being walked is between style and mannerism, which is much easier to identify, and easy to fall into by trying too hard to develop a style. The technique or trick takes over and you end up with a series of images that are distinct, but too deliberate. And viewers don't like having style pushed in their faces; it is similar to explaining a joke at the same time as telling it. Probably most photographers go through some stages of experiment with this or that technique, whether during picture-taking or processing, but getting stuck in something as noticeable as, say, color-graduated skies, is generally a shallow idea. That said, the term style is often used vaguely, particularly in relation to individuals, whether painter or photographer. We are on safer ground when talking about collective works, schools, and movements. In that sense, style is definition.

Here, I'm restricting the definition even further and limiting it to the way in which photographers handle color. It's important to try and distinguish between style and technique, as the latter, which is easier to identify, is commonly confused for style. I say "try" because there are no clear lines of division, and technique (including, for example, using flash to eliminate shadows and so increase the area of bright color) builds up to style.

Techniques for handling color in photographs are straightforward to grasp and use, and many of them are described in this book. Some tend toward the procedural, as in a sequence of actions in Photoshop to select and shift certain colors. Others are observational—a way of choosing color combinations by composing and framing. Whatever the techniques used, they tend to add up to a style through the exercise of choice and creative judgment, all with a purpose. Among painters, for example, we could look at the identifiable colors of Van Gogh, Matisse, or Francis Bacon.

Among photographers there are a number of well-known colorists whose work is recognizable simply by their choice of, and management of, color. Generally, they've either established an identifiable color style or else concentrated so single-mindedly on it that it has become, in effect, theirs. Among the most obvious are Joel Meyerowitz, Jan Groover, Ernst Haas, Martin Parr, Alex Webb, and Eliot Porter, each very different from the other.

Finally, you might argue—and it has been, often—that any style is a limitation, and a talented photographer should be above this and be able to draw on a wide and varied set of skills according to the situation and the job at hand. Style is sometimes just in the eye of the person looking at photographs, rather than in the mind of the photographer taking them.

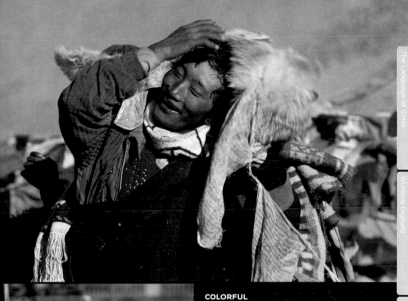

COLORFUL

Above: Again, where the situation makes it possible, the evident enjoyment of colorful scenes is a stylistic choice, as in this image of a Tibetan pilgrim at the highest point in the circumambulation of Mount Kailash.

MINIMALIST COLOR

Left: Being drawn to a single strong color, and adjusting the framing and exposure to focus on it, is one kind of style. As in all reportage photography, it depends first on opportunity.

Rich & Intense

In color photography, the principal stylistic dispute remains between dramatic and restrained color, with the former winning the popularity stakes but at the receiving end of art criticism.

While there are many color styles possible in photography, particularly now that digital imaging allows such thorough control and manipulation, the lines are drawn most firmly between rich and delicate palettes. Most color styles can be placed quite legitimately in one or the other group.

The dispute erupted in the 1970s with the emergence of what became known as New Color, principally in the United States. Although the new photographers, including William Eggleston and Stephen Shore, worked independently, they had certain identifiable characteristics in common, including a retreat from the obvious and dramatic, a celebration of the ordinary, and a largely deadpan approach to color with a strong conceptual component.

In fact, what they especially had in common was that their work was not much like the kind of color photography that has always been generally popular— with rich, saturated, strong colors— and it was this negative definition that made them largely favored by museum curators. The photographer most strongly associated with saturated colors, and a firm, colorful choice of scene and subject, was Ernst Haas. Very popular in his heyday, Haas was an influence on Pete Turner, Jay Maisel, and Galen Rowell, as well as color magazine photography, as in *National Geographic* and *GEO*.

PALM OIL
There were many ways of photographing these bottles of palm oil for sale in a Sudanese market, but this shot goes deliberately for maximum color by closing in, shading the lens, and using the sun as backlighting.

The trait of saturated colors and good contrast was originally very much associated with Kodachrome. When slightly underexposed, its colors become richer, and this became a common professional technique. To its users, Kodachrome made color photography exciting (and for many years *National Geographic* used nothing else), but to the art crit lobby it was anathema. Pete Turner could claim: "I've been noted for my strong and rich color saturation and I couldn't have achieved it without Kodak," but at the same time, Haas was referred to pejoratively by one critic as the "Paganini of Kodachrome." Szarkowski, who made no secret of his rejection of

POPPY FIELD

A poppy field near Salon-de-Provence, France, sits in front of a background of vibrant green foliage, a classic powerful red and green color combination. Perhaps somewhat counter intuitively, overcast skies rather than bright sunshine are the best conditions in which to capture bright natural color.

sensational, popular color photography, damned Haas with faint praise by writing: "The color in color photography has often seemed an irrelevant decorative screen between the viewer and the fact of the picture. Ernst Haas has resolved this conflict by making the color sensation itself the subject matter of his world."

Velvia film from Fuji eventually took the mantle of delivering saturated colors from Kodachrome, and it's interesting to look at the influence of film brands on color style from the newer perspective of digital photography. The effects that are

either loved or despised are not only now measurable in saturation and per channel contrast, but completely malleable. Rich colors, golden evening sunlight, rainbows, chiaroscuro, and shafts of light piercing darkness are all part of a way of seeing. They are, above all, popular—easy to enjoy and not especially demanding. Try taking a set of digital photographs on screen in Photoshop, put aside any idea that they might have a "correct" appearance, and choose the level of saturation or desaturation that you prefer. Most people opt for more rather than less saturation.

Restrained & Commonplace

Desaturated palettes carry with them overtones of sophistication and subtlety, and a deliberate rejection of the popular, but handling them demands a sure touch to avoid being simply ordinary.

On the other side of the art critical line is restrained color. This is an argument that goes back much further than photography, and "a disdain for color" as John Gage puts it, has in a number of cultures "been seen as a mark of refinement and distinction." And while the debate really got going in the 1970s, it had its beginnings with the availability of color film. Before this, photographers became comfortable with black and white despite what might be thought of as its shortcomings, not least because its monochrome palette made a point of distinction from painting, with which early photography was often compared. The arrival of color complicated the aesthetic of interpreting the visible world, or, in Szarkowski's words: "For the photographer who demanded formal rigor from his pictures, color was an enormous complication of a problem already cruelly difficult."

Color was harder to control, too. Colorists in the style of Ernst Haas had difficulty finding the scenes, viewpoints, and lighting that would deliver the richness and spectacle they wanted, but those who insisted on restraint and nuance had an equally demanding task. One solution was to shoot in controlled studio conditions, or at least indoors (Jan Groover, for example), where the lighting could be altered and things moved. An outdoor alternative was to shoot at times of day when the light would be less definite, such as dusk, or in overcast weather conditions. In color terms, revealing nuance means paying extra attention to the context—surrounding tones and colors. Juxtaposition and composition are as important as in rich-color photography, but need to be exercised differently and usually with more fine tuning, even more slowly. Digital photography has transferred some of this work to post-production, and can give the photographer more freedom.

One technique for restraining color is to work with a limited palette, imposing a kind of unity on the image by choosing to shoot colors that are similar in one way or another (either hue, saturation or brightness). To quote an example from one of the New Color photographers, the American Joel Meyerowitz made a series of landscapes around Cape Cod, paying particular attention to the unity imposed by light. On one occasion he was struck by the overall impact of blue on the scene, writing about: ". . . blueness itself. It was radiant. It had depth. It had everything I might possibly compress in my whole being about blue." In fact, Meyerowitz, although often lumped in with Eggleston, Shore, and others for critical purposes, was more of a formal colorist.

VICTORIAN KITCHEN

Left: Dust and age have combined to fade the already subdued colors of an abandoned kitchen that was part of an old English country estate. Shooting toward the light further reduces the saturation.

OLD TEA HOUSE

Left: Despite the contrasting light, the building materials—namely wood and stone—create a limited color palette, to which is thrown in the mix the old man's essential brown clothing, which complements the scene as a whole.

Color & Place

The colors associated with scenery, local weather, land use, and culture can in some locations be so characteristic that they help to give definition to the sense of place.

A recurring theme in photography, particularly of the kind that involves traveling and reportage, is that of the essence of place—the idea that there are visual characteristics sufficiently distinctive to capture in a well-chosen set of photographs. Often this is ambitious, because in practice many of the most telling images in photography have a universality that transcends location. Nevertheless, travel photographers, and

SAN GIMIGNANO

Much of the medieval town of San Gimignano in Tuscany, Italy, is built out of volcanic tuff, a type of consolidated rock common in this region of Italy. Although generally unassuming in color, the rock is closely associated with this area and its spectacular architecture and scenery.

those who explore a specific territory, try by various means to define a sense of place, and color is one of the qualities that they use.

The extent to which a place or culture can legitimately be said to have its own identifiable color palette depends partly on the individual photographer, which is

perfectly in accord with the personal
subjectivity of color. It also depends on
how distinctive it is as a location, and
how much it is set apart from elsewhere.
The factors that contribute the most
to this color definition are the basic
elements of the habitat —rock, soil,
vegetation, and the way in which the
land is used, all modulated by season,
climate, and day-to-day weather.
Occasionally, people refer to the special
quality of light in one place, and this
may indeed be partly due to some special
condition of atmosphere—crystal clear in
the high Himalayas, for example, or even
a kind of beneficial pollution such as the

MACHU PICCHU
Machu Picchu, the famous "Lost City of the Incas,"
is a pre-Columbian 15th-century Inca site located
2,430m above the Urubamba Valley in Peru. At this
altitude skies are often intensely blue and the light
piercingly sharp.

haze of burning cow dung in parts of
rural India in winter, or the smog that
used to give Athens its famous sunsets
before it was cleaned up.

Case Study: **New Mexico**

Some places simply have more of an identifiable personality than others. New Mexico is one of these, in particular the area around Santa Fe and Taos Pueblo. It has a history of adobe building that gives it an architectural character, and has drawn artists and photographers who have in turn embellished and enhanced its color palette. Adobe is rammed-earth construction, ideal for a land that has limited forests but easily accessible earth—and little rainfall. Style and color are principally a fusion of the pueblos and the Spanish settlers.

CHILLIES

Left: Adobe, turquoise wood, and red chillies strung to dry could almost be seen as a signature motif—a detail that identifies this region of North America.

COTTONWOOD

Left: Cottonwood trees are characteristic of New Mexico's flora, and in fall add a range of hues from yellow-green to orange.

KIMO THEATER

Left. Opened in 1927, the KiMo theater (named after "mountain lion" in one Pueblo dialect) in Albuquerque is a magnificent example of locally inspired Art Deco. These ceramics and other decorations are the work of Hollywood architect Carl Boller, who painstakingly researched the colors and motifs of both the pueblos and the Spanish mission styles.

EARTH, SKY, TREES

Left: One of the area's classic adobe dwellings is the Trigg House, built in Spanish mission style, with an interior courtyard. In this one shot the basic elements of New Mexican color are apparent: warm earth with splashes of bright color from the sky and fall cottonwoods.

COLOR ACCENT

Right: A different shade of blue-green colors a window frame set below a roof water spout in another pueblo—San Ildefonso. Here the adobe is from a warmer-toned earth. As in the other images here, an adjacent color bar shows the key colors at a glance.

COUNTRY MARKET

Left: The ranges of blue that New Mexicans choose are always interesting, even though, in most cases, a conscious sense of design does not play a part. The blues rarely stray toward violet and purple; denim dungarees are about as far from green as the range goes. The metallic color of the old pickup is especially fine, and a wonderful accompaniment for chillies and pumpkins being brought to market.

THE MABEL DODGE HOUSE

Left: The area attracted artists from the beginning of the 20th century, and the house of Mabel Dodge in Taos became a salon whose visitors included D.H. Lawrence—who decorated this corner fireplace in the stylistic mixture of local Hispanic and Taos Pueblo artisans.

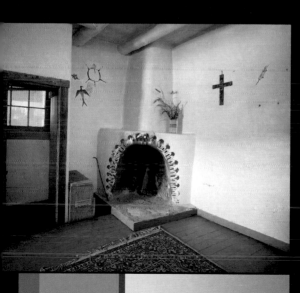

Urban Colors

The man-made environment of towns and cities has its own special palette in which a backdrop of desaturated, even drab, tones is set against the localized, synthetic colors of display and advertising.

Just as the rock, earth, plants, and water of natural habitats create a color signature of place, so man-made environments are distinctive. Completely urban locations (excluding the parks and gardens that are maintained precisely to soften the environment with touches of nature) have identifiable color palettes, some of which are common to the majority of cities and towns. If you are shooting in these with an eye to exploring color, there are some potentially interesting subtleties and contrasts.

The subtleties are mainly in the materials of construction, which tend to be similar in any one location for practical reasons. In modern cities, gray predominates. It is the color of concrete, asphalt, most stone, and steel. Even glass, often used in large expanses in city centers, with little color of its own, simply reinforces the dominant gray by reflection—especially in overcast weather. Cloudy days reduce contrast in any case, and give full play to the nuances of gray, though whether you choose to see these as drab and depressing or subtly complex—as William Eggleston has—is a matter of personal attitude.

Older cities, and city centers where older buildings have been preserved, tend to be more distinctive due to idiosyncrasies in the materials used to build them. The center of the university town of Oxford, England, for example,

SHIBUYA CROSSING

Above: Umbrellas bring a variation of color to the Shibuya Crossing, Tokyo, one of the busiest pedestrian crossings in the world.

contains many buildings—colleges and churches mainly—constructed from the local limestone, which varies in appearance from a creamy gray during the day to a soft orange in the light of a low sun. As another example, the remaining parts of many tropical, former-colonial cities, such as in Singapore, often feature whitewashed buildings and shade trees, which in the middle of the day create a particular kind of high-contrast chiaroscuro in white, black, and green.

In complete contrast to the plainness of most large-scale urban scenes are the

TOKYO

Above. A bridge in downtown Tokyo, near Ochanomizu, as night falls. The chiaroscuro of lights is typical, here enhanced by reflections in the water. The usual problem of photographing at night is to retain a sense of form, and here the bridge helps.

GLASS WALLS

left A glass-clad building in Phoenix, Arizona, used for its reflections by shooting close with a wide lens

bright color accents of signs, shop fronts, advertising hoardings, vehicles, and displays in general. What these all have in common is the need to attract attention through bright colors, either for warning, advertising, or amusement. As night falls in city centers, these become even more insistent. In terms of color saturation, many urban scenes brighten at dusk.

The Colors of Still-life

Still-life, traditionally the genre for making rather than taking photographs, allows a blank canvas on which colors can be placed and arranged.

Paul Outerbridge (1896–1958), one of the earliest still-life photographers of note to work in color, wrote in 1940 that this genre offered the greatest possibilities "for purely creative work in color photography." This is not surprising to hear for anyone who wants to exercise the kind of absolute control that painters have always had, and Outerbridge was followed by a succession of photographers of a particular personality: deliberate, measured, and considered. These included Irving Penn, Hiro (Yasuhiro Wakabayashi), Henry Sandbank, and Lester Bookbinder.

Nor is it any coincidence that the work of all these photographers bridged the creative and the commercial aesthetics. Advertising and fashion editorials in particular needed still-life in order to show products and express concepts in a tightly controlled manner. This is the antithesis of street photography, and nothing is left to chance. Absolutely everything is imported into the frame, and any shortcomings or failures are laid right at the door of the photographer (or art director). This affects the color as much as any other component of the shot, and in this way still-life allows the ultimate expression of color discrimination. It did also in painting, with artists such as Jean Baptiste Siméon Chardin (1699–1779) and Georges Braque

SHAKER KITCHEN

Left: Spit-roasted chicken in a reflector oven, with a tin colander and stoneware preserving jar, at a Shaker village in Kentucky. The attraction of the arrangement lies heavily in the concordance of browns and beige.

(1882–1963), who used it as a vehicle for exploring truth and nature. In painting, the creation of color from pigments was and remains an issue that spans the entire process. In most photography, the colors are normally in place before the photographer starts to work, but with still-life they can be selected with precision. In the hands of someone like Irving Penn, arguably one of the greatest of the genre, a commissioned commercial piece can transcend the immediate job into art.

With the choice of palette completely open to the photographer, it is little surprise that there is great variety in color still-life. Nevertheless, precision and discrimination are always obvious in any good, well-thought out shot. Many photographers are drawn to simplicity and restraint, with the accompanying demands that this makes on getting subtle hues and neutrals absolutely accurate—now completely achievable with digital post-production. Others opt for combinations of intense colors that are difficult to find in real life.

ARTIST'S STUDIO

Top left: Although an active atelier, or studio, belonging to the Shanghai-based, French painter Christian de Laubadère, the space has the appearance in itself of a still-life. Artificial colors, such as the strong blues and greens of the china, combine with the natural colors of the fruit.

BLUE BOTTLE

Left: The subjects were two old bottles, and the treatment was to abstract them into shape and color, arranging them for a simple set of lines. The bottle at left was in blue glass, and to set this off, the other was filled with blue-dyed water, then aerated via a pipe to give it life.

Selective Enhancement

By using the selection and color-shifting tools, it's possible to draw attention to color relationships that might otherwise be missed. To remain realistic, this procedure should normally be applied delicately.

The most sensible tool to use is one that can distinguish hue, as the premise for this operation is that existing colors are being altered, versus adding new ones. There are several image-editing methods, but the most generally useful are the various HSB/HSL controls. First the color range is chosen, either by selecting a preset range such as Reds or Yellows, or by moving sliders along a bar that shows the entire range to choose one part of it. A starting point for a particular color in a photograph is to use the selector eye-dropper on the image, and then tweak the range sliders.

With the color, or colors, selected, the hue, saturation, and lightness (or luminance) can all be shifted by means of sliders, and this was the method used in the example here and on the preceding pages. Exercise caution when significantly altering the values of a color; it is all too easy to go too far, particularly in hue and saturation changes (brightness differences are always less intense). Color realism is considered a fragile commodity in photographs.

A CLASSIC HARMONY

The aim here was to strengthen what already had
the makings of an established harmony between
yellow and violet, in a dawn view of fishing boats in
the Gulf of Thailand. As shot (opposite), the harmony
is just suggested, and the brightness of the sky in the
uppermost gap in the clouds has drained the color that
persists in the lower two patches. Because there is no
yellow at the top to enhance, the bright areas were first
selected as a color range, and this selection then filled
in a separate layer with yellow. This was blended as an
overlay with the main image. Then the lower patch of
color was adjusted to make it less orange, and the third
also brought into line. Finally, the violet suffusing the
clouds and sea was colorized and enhanced.

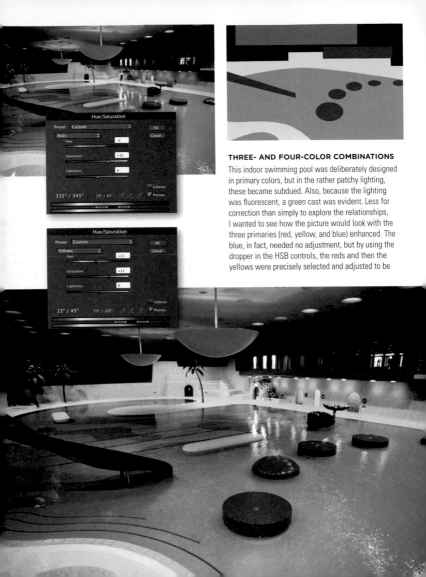

THREE- AND FOUR-COLOR COMBINATIONS

This indoor swimming pool was deliberately designed in primary colors, but in the rather patchy lighting, these became subdued. Also, because the lighting was fluorescent, a green cast was evident. Less for correction than simply to explore the relationships, I wanted to see how the picture would look with the three primaries (red, yellow, and blue) enhanced. The blue, in fact, needed no adjustment, but by using the dropper in the HSB controls, the reds and then the yellows were precisely selected and adjusted to be

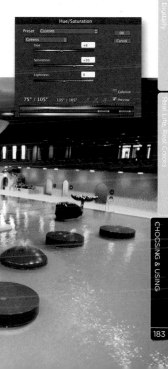

as pure as possible. There was still the rest of the scene to consider, most of it a murky green. In the first adjustment, these areas, mainly water, were neutralized by desaturation so that they became the ground for the interplay of bright primaries. But a second alternative also suggested itself—to enhance the green for a more complex combination of four hues.

Distressed Color

There is a wide range of digital filter effects dedicated to stylizing color, which is to say creating a non-realistic color character for an image by means that are usually the opposite of optimization.

In the same way that new-for-old furniture can be given a patina of age by distressing its surface, colors in a photograph can be processed to give them a worn, used look. One reason for doing this is to make the image seem older, giving it the dark characteristics of, say, an Autochrome (early color film) or a hand-colored black-and-white print. Another is simply to move the image away from the crisp actuality of a photograph into a realm closer to painting. For this second direction there

are digital techniques, mainly proprietary, for giving the appearance of brushstrokes, scumbling, and other painterly ways of applying color. There is often an element of pastiche about this, and it will be of no interest to reportage photographers, for example. Nevertheless, the results can in their own terms be attractive, evocative and, above all, atmospheric. Distressed color is particularly effective in prints and on textured paper, for which the new generation of desktop inkjet printers offers

LIGHTROOM

Below: Although Lightroom's presets don't offer much in the way of control (unlike Photoshop's Filters), they can provide an instant look; and new presets and plugins are released daily. A search on the internet will reveal hundreds.

endless opportunities to experiment.

As in any form of distressing, the process involves several to many stages, and the imaginative use of techniques not originally designed for editing images in this way. From a software point of view this tends to be complicated rather than difficult, and the distressing of color is now a category of color effects presets in software such as Lightroom. It has also attracted independent software companies who have created plugins. What most of them offer is a conveniently packaged set of procedures with an identifiable style of result. You could reproduce nearly all of these using Photoshop, if you were prepared to take the time to experiment, and for occasional use on a specific image

this is probably the best approach for anyone who enjoys playing with the more obscure Photoshop controls. However, price generally reflects utility in software, and these third-party plugin filters are usually inexpensive and often part of larger filter suites.

ALIEN SKIN

Right & above right. Alien Skin have been creating powerful graphics software since 1993. Their extensive product lineup includes Exposure and Snap Art. The former replicates a staggering range of film types including Fuji Velvia and Kodak Ektachrome, as well as numerous movie and vintage film looks (as shown here) and a host of lo-fi camera and cross-processing looks—all of which are customizable. Snap Art features numerous drawing, painting, and sketching effects. As with Exposure, the effects are fully adjustable.

Case Study: **Unreal Color**

Until now, photography has not had the technical opportunity to render colors in any way the artist pleases. Digital imaging, however, allows total manipulation of color, as we have partly seen already. Add the techniques of

selection discussed earlier to the methods of altering color that we looked at on pages 180–83, and you have a powerful set of tools that you can use to express the color of an image as you like—and as radically as you like.

Replace Color

Selection
Localized Color Clusters

Color:

Fuzziness: 153

○ Selection ● Image

Replacement

Hue: +138

Saturation: +42

Lightness: +20

OK
Cancel
Load...
Save...
☑ Preview

Result

Glossary

APERTURE

The opening behind the camera lens through which light passes on its way to the sensor.

BACKLIGHTING

The result of shooting with a light source, natural or artificial, behind the subject to create a silhouette or rim lighting effect.

BIT (BINARY DIGIT)

The smallest data unit of binary computing, being a single 1 or 0.

BIT DEPTH

The number of bits of color data for each pixel in a digital image. A photographic-quality image needs 8 bits for each of the red, green, and blue channels, making for a bit depth of 24.

BRACKETING

A method of ensuring a correctly exposed photograph by taking three shots: one with the supposed correct exposure, one slightly underexposed, and one slightly overexposed.

BRIGHTNESS

The level of light intensity. One of the three dimensions of color in the HSB color system. See also *Hue* and *Saturation*

CALIBRATION

The process of adjusting a device, such as a monitor, so that it works consistently with others, such as scanners or printers.

CHANNEL

Part of an image as stored in the computer: similar to a layer. Commonly, a color image will have a channel allocated to each primary color (e.g. RGB) and sometimes one or more for a mask or other effects.

COLOR TEMPERATURE

A way of describing the color differences in light, measured in degrees Kelvin and using a scale that ranges from dull red (1,900K), through orange, to yellow, white, and blue (10,000K).

CONTRAST

The range of tones across an image, from bright highlights to dark shadows.

DIFFUSION

The scattering of light by a material, resulting in a softening of the light and of any shadows cast. Diffusion occurs in nature through mist and cloud cover, and can also be simulated using diffusion sheets and soft-boxes.

EDGE LIGHTING

Light that hits the subject from behind and slightly to one side, creating flare or a bright "rim lighting" effect around the edges of the subject.

FILTER

(1) A thin sheet of transparent material placed over a camera lens or light source to modify the quality or color of the light passing through. (2) A feature in an image-editing application that alters or transforms selected pixels for some kind of visual effect.

FRINGE

In image editing, an unwanted border effect to a selection, where the pixels combine some of the colors inside the selection with some from the background.

GRADATION

The smooth blending of one tone or color into another, or from transparent to colored in a tint. A gradated lens filter, for instance, might be dark on one side, fading to clear on the other.

GRAYSCALE

An image made up of a sequential series of 256 gray tones, covering the entire gamut between black and white.

HAZE

The scattering of light by particles in the atmosphere, usually caused by fine dust, high humidity, or pollution. Haze makes a scene paler with distance, and softens the hard edges of sunlight.

HISTOGRAM

A map of the distribution of tones in an image, arranged as a graph.

HSB (HUE, SATURATION, BRIGHTNESS)

The three dimensions of color, and the standard color model used to adjust color in many image-editing applications.

HUE

The pure color defined by position on the color spectrum; what is generally meant by "color" in lay terms.

ISO

Traditionally an international standard rating for film speed, with the film getting faster as the rating increases. In digital cameras the ISO setting represents the sensitivity of the sensor.

LAYER

In image editing, one level of an image file, separate from the rest, allowing different elements to be edited separately.

LUMINOSITY

The brightness of a color, independent of the hue or saturation.

MASK

In image editing, a grayscale template that hides part of an image. One of the most important tools in editing an image, it is used to limit changes to a particular area or protect part of an image from alteration.

MIDTONE

The parts of an image that are approximately average in tone, falling midway between the highlights and shadows.

NOISE

Random patterns of small spots on a digital image that are generally unwanted, caused by non image-forming electrical signals.

PIXEL (PICTURE ELEMENT)

The smallest units of a digital image, pixels are the square screen dots that make up a bitmapped picture. Each pixel carries a specific tone and color.

PLUGIN

In image editing, software produced by a third party and intended to supplement a program's features or performance.

PPI (PIXELS-PER-INCH)

A measure of resolution for a bitmapped image.

REFLECTOR

An object or material used to bounce available light or studio lighting onto the subject, often softening and dispersing the light for a more attractive end result.

RESOLUTION

The level of detail in a digital image, measured in pixels (e.g. 1,024 by 768 pixels), lines-per-inch (on a monitor), or dots-per-inch (in a half-tone image, e.g. 1,200 dpi).

RGB (RED, GREEN, BLUE)

The primary colors of the additive model, used in monitors and image-editing programs.

SATURATION

The purity of a color, going from the lightest tint to the deepest, most saturated tone.

SELECTION

In image editing, a part of an on-screen image that is chosen and defined by a border in preparation for manipulation.

WHITE BALANCE

A digital camera control used to balance exposure and color settings for artificial lighting types.

ZOOM

A camera lens with an adjustable focal length, giving, in effect, a range of lenses in one. Drawbacks include a smaller maximum aperture and increased distortion over a prime lens.

Index

Acknowledgments

AUTHOR'S ACKNOWLEDGMENTS

The author would like to thank the following for all their assistance in the creation of this title:

Filmplus Ltd, Nikon UK, REALVIZ, and nikMultimedia.